LEGENDARY LOC

—— OF ——

CARLSBAD

CALIFORNIA

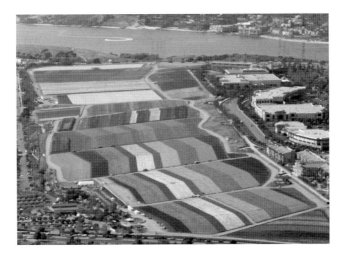

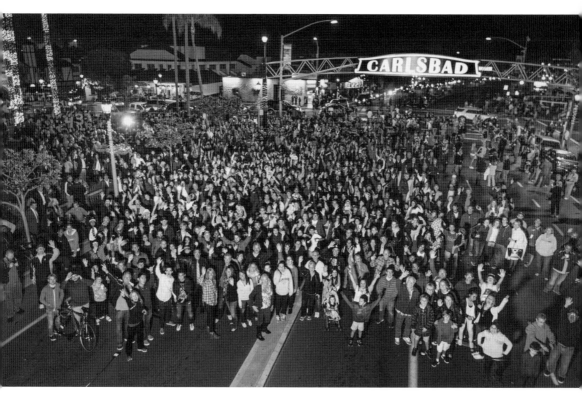

Carlsbad

The Carlsbad sign, which was dedicated on January 8, 2015, was inspired by a similar archway that stood in nearly the same location during the 1930s. It spans Carlsbad Boulevard at Carlsbad Village Drive. (Courtesy of Lorenzo Menendez, *Carlsbad* magazine.)

Page I: Flower Fields

The Flower Fields at Carlsbad Ranch contains 50 acres of giant tecolote ranunculus flowers, which cascade beautifully down the hillside in a bloom of color overlooking the Pacific Ocean. (Courtesy of Carlsbad Flower Fields.)

LEGENDARY LOCALS
—— OF ——

CARLSBAD
CALIFORNIA

CYNTHIA MESTAD JOHNSON

LEGENDARY
LOCALS

Legendary Locals is an imprint of Arcadia Publishing
Charleston, South Carolina

Printed in the United States of America

Library of Congress Control Number: 2015947221

For all general information, please contact Arcadia Publishing:
Telephone 843-853-2070
Fax 843-853-0044
E-mail sales@arcadiapublishing.com
For customer service and orders:
Toll-Free 1-888-313-2665

Visit us on the Internet at www.arcadiapublishing.com

Dedication
For Casey and Ayla, forever in my heart

On the Front Cover: Clockwise from top left:
Abel Garcia (Courtesy of the Garcia family; see page 46), Cody Lovaas (Courtesy of Candice Johnson; see page 121), Marshall Lubin (Courtesy of M. Lubin; see page 115), John Haedrich (Author's collection; see page 54), Manuel Castorena (Courtesy of the Carlsbad Public Library Carlsbad History; see page 36), Georgina Cole (Courtesy of Courtesy of the Carlsbad Public Library Carlsbad History; see page 42), Beth and Brad Thorp (Courtesy of the Mitchell Thorp Foundation; see page 85), Scott Chandler (Courtesy of S. Chandler; see page 118), Sam Thompson (Courtesy of Carlsbad Historical Society; see page 66).

On the Back Cover: from left to right:
The Gastelum family (Courtesy of the Dominguez family; see pages 11 and 12), Doug Green (Courtesy of Jerry Chen; see page 100).

CONTENTS

Acknowledgments 6

Introduction 7

CHAPTER ONE Collision of Cultures 9

CHAPTER TWO Baby Boomers to Gen X 29

CHAPTER THREE It Was Their Destiny 51

CHAPTER FOUR Visionaries 81

CHAPTER FIVE Livin' the Dream 105

Index 127

ACKNOWLEDGMENTS

It goes without saying that this project was a collaborative effort. While the written pieces are all my own (this is my disclaimer), I would like to thank the following people for their assistance in helping me to connect with some of our local legends.

My deepest gratitude to Kevin Bender and Mike Calarco (Leo Carrillo Ranch Historic Park), Amy Davis (Carlsbad History Room, Cole Library), Cindi Donaldson, Sue Gutierrez (Carlsbad Historical Society), Brian and Tracy Kennedy, Paige Maslen (Army and Navy Academy), Marianne and Pat Quindoy-Senteno, and Amanda Waters (athletic director, Carlsbad High School).

Thanks to my technical support and editing team: Sharrie Allen, Tim Clinton, Jamie Williams Holland, and Erin Vosgien.

Finally, a huge thank-you to my legendary husband, Bill, for putting up with yet another literary project.

All images, where not otherwise noted, are from the author's collection.

INTRODUCTION

Carlsbad has a rich history for such a young town. Historic neighborhoods are scattered from the Barrio to Highland Avenue and beyond. Multigenerational families still refer to the main street through town as Elm. The original adobe home built by the first family to receive a land grant, the Marrons, still stands and is occupied by a direct descendant. However, what makes Carlsbad truly special are the people. This is where the ordinary coexist with the extraordinary as equals. This book contains a very small and diverse sampling of the individuals, both past and present, who have made this town great. Carlsbad has swelled to well over 100,000 in population, yet it feels like an extremely intimate village where your close friends live. The people are the true heart of this town. To include them all would be preferred, but sadly there was limited space.

Today, Carlsbad is known for many year-round outdoor activities. Locally, it is famous for three lagoons, one of which is used for water sports and fishing, and the other two are protected water habitats. There are miles of well- groomed hiking trails, many with a view of the Pacific Ocean. Locals enjoy the pristine coastline and white-sand beaches 12 months out of the year, but if you are a visitor, only here for a moment in time, the residents will cautiously share their space. There are surf lessons, bicycle rentals, and volleyball courts available at the beach. Take a stroll through the historic village, and it will offer you the perfect ending to an epic day. With live music in many restaurants, pubs, and coffee shops, your biggest decision is choosing which establishment to settle in for the evening. Twice a year, Carlsbad holds the largest street fair in the state. Add to that Brewfest, Oktoberfest, ArtSplash, the Carlsbad 5,000 and marathon, professional golf and tennis tournaments, four golf courses, LEGOLAND, award-winning plays in our own theater, the Flower Fields, the Museum of Making Music, art galleries, and the finest street art south of Los Angeles, there are too many activities and opportunities to list and not enough days in the year to enjoy them all.

The "Village by the Sea" is where many call home. It has also become a coveted vacation spot both nationally and internationally as a result of the average temperature of 70 degrees and more than 265 days of sunshine. Carlsbad is a family-oriented business-friendly surf mecca that has something for everyone.

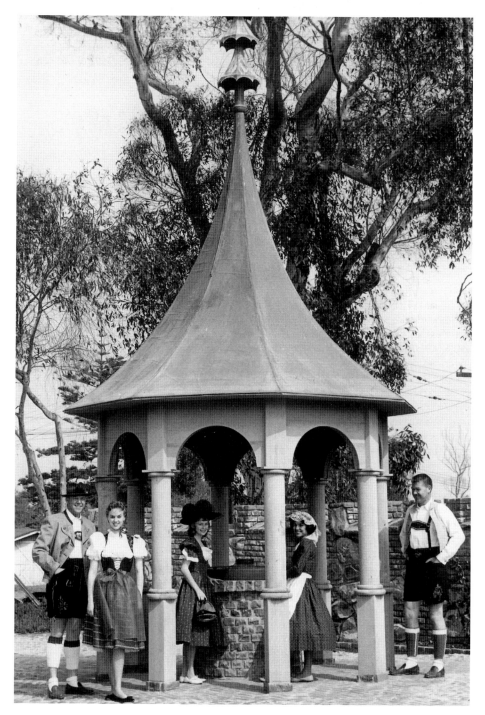

Frazier's Well
Frazier's Well, pictured here around 1960, was the chosen location for the city of Carlsbad to create a promotional photograph for tourism. The students that were chosen for this photo opportunity are dressed in traditional Bavarian clothing. (Courtesy of Linda Slater.)

CHAPTER ONE

Collision of Cultures

Carlsbad's story began long ago with the Luiseño Indians, who came from the San Luis Rey band of Mission Indians. They were settled for generations on the south side of Agua Hedionda Lagoon, where they lived, worked, and worshipped next to the natural water source. Driven by westward expansion and the Mexican Revolution, this primarily uninhabited area experienced a convergence of two new cultures, each one complementary to the other, and together created the idea of Carlsbad. They were equally drawn by the promise of a new beginning in a beautiful setting with the perfect climate and endless opportunities. Their enthusiastic spirits combined with individual talents created a mix of individuals exclusive to Carlsbad's character today.

Many events occurred, nearly simultaneously. The discovery of mineral water with "healing powers" emerged. The installation of the Santa Fe Railroad passing through town became a welcome rest stop for travelers headed south. The Hispanic residents created a vibrant neighborhood with an intense entrepreneurial spirit that overflowed into the village. The town began to grow.

The barrio had a small church, Metodista Iglesia, a store, and a very popular pool hall. Most of the residents worked in the agricultural industry, but there were also those who became businessmen. The streets were dirt, the homes had gardens, and many families had some animals, chickens, pigs, cows, or goats. It was a friendly neighborhood—it still is. It was the epitome of "it takes a village," with everyone relying on each other and lending a hand when there was a need. When there was a celebration in life or death, everyone showed up, but never empty handed.

Within a few short blocks, the discovery of mineral water had developed into the building of Frazier's Well, which evolved into a popular tourist attraction. Ideally, the next step would be a restaurant on the same block. The second owners of Twin Inns developed the idea of a simple, but delicious, chicken dinner. It did not take long to realize that a boxed chicken lunch for passengers from the train would be a perfect complement to their newly purchased mineral water. Finally, a hotel and spa were added across the street from the restaurant and mineral well. The transition happened from a railway rest stop to a popular place to go for a holiday. The entrepreneurial spirit had a rich platform from which it would grow, and it was only the beginning.

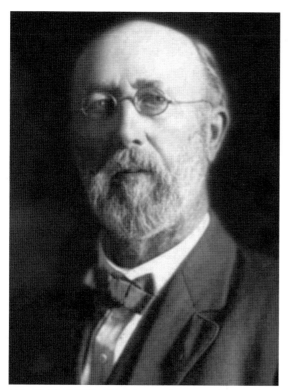

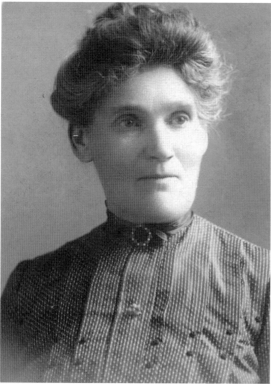

Gerhard and Bertha Schutte
Known as the "Father of Carlsbad,"
Gerhard Schutte was bestowed the
honorable title for his participation in
helping to create the Carlsbad Land and
Water Company, having a love for the
water drawn from Frazier's well. Before
moving to the seaside village, Schutte
had fought in the Civil War for the Union
army and participated in battles such
as Gettysburg, Chancellorsville, and
Antietam, making him a hero in his own
right. Having garnered great success with
his real estate company in town, Gerhard
built the first of two hotels, Twin Inns.
Pictured here are Gerhard and his wife,
Bertha. (Both, courtesy of Carlsbad
Historical Society.)

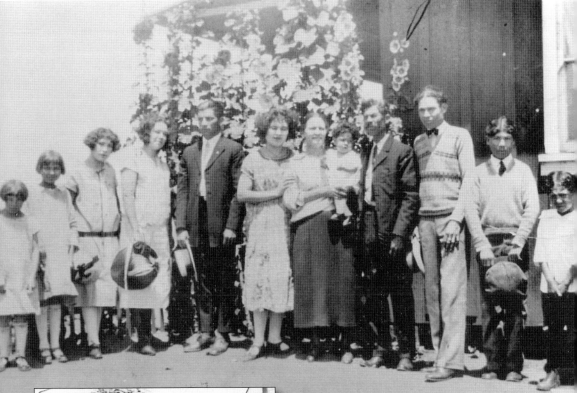

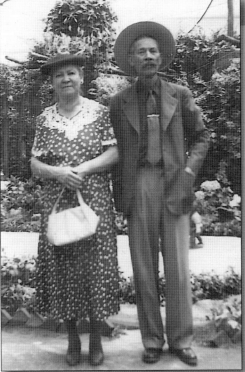

Bibiano Ochoa Gastelum
Born in Sonora, Mexico, in 1873 and one of 11 children, Bibiano worked as a caballero (cowboy) as a young man. He moved to Arizona at the turn of the 20th century, where he met and married his wife, Josefa, in 1901; she was 10 years his junior. In 1908, Bibiano was bitten by a rattlesnake and forced to chop off his hand with an ax. One week later, doctors had to amputate his arm at the elbow to save his life. This is when Bibiano needed to make the transition to farming, and he eventually moved to Carlsbad, where his 12th child was born, in 1924. Bibiano and his wife owned a home on Roosevelt Street and purchased the pool hall from the Villaseñor family. Bibiano was highly respected and loved in the barrio. (Courtesy of the Dominguez family.)

Boys of the Barrio
World War II had a deep impact on the families of the barrio. Many of the young men left their families with every reason to wonder if they would return. The Gastelum family was possibly affected the hardest—22 first cousins were deployed. But before they left, they made a pact. They prayed to God for a safe return of the 22 young men, and if this was to be, once they were all together again, they would make a pilgrimage to Sonora, Mexico, to the Father Kino Mission and pray their thanks. Only 21 of the cousins returned. Feeling as though God had not let them down, the remaining cousins still made their pilgrimage to Sonora in 1948 to give thanks for a safe return to their families at the Father Kino Mission. Pictured here are the younger Gastelum siblings of the deployed cousins. (Courtesy of the Dominguez family.)

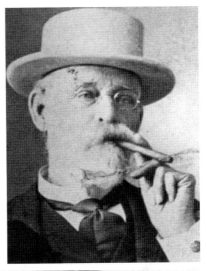

Samuel Church Smith
One of the founders of the Carlsbad Land and Water Company, Samuel Church Smith was the first owner of the Magee house. The house is architecturally unique for the area and well known to its residents. When the economy took a downturn in the 1890s, Smith was forced to sell his home to Alexander Shipley. (Courtesy of the Carlsbad City Public Library Carlsbad History.)

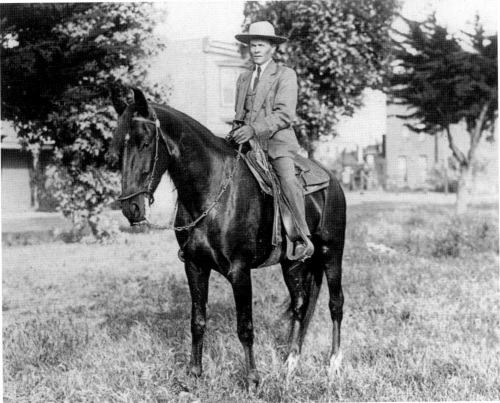

Hugh Magee
A descendant from the Estudillo family from Old Town, an original Californio family of Spanish decent, Hugh Magee became a well-known rancher in Carlsbad. In 1912, he swept Florence Shipley off her feet, much to her father's despair, and the two eloped. This resulted in their temporary relocation from Carlsbad to Pala on a new ranch, which he named Condor's Nest. (Courtesy of the Carlsbad City Public Library Carlsbad History.)

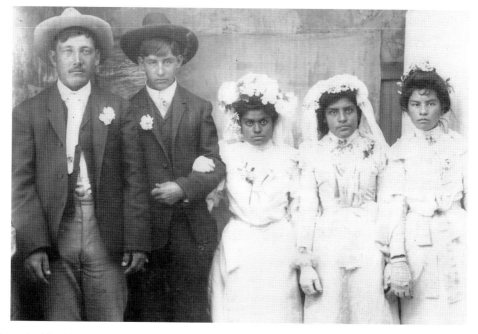

Ricardo Martinez

Born in Texas in 1887, Ricardo Martinez married 16 year-old Estanislada at the age of 17. The Martinez family moved to Carlsbad to join Ricardo's brother. Estanislada died after they arrived while pregnant with her 13th child. Suddenly a widower with 12 children, Ricardo remarried Sophia, a widow with one child. Together, they had 11 children, rounding the number to 24. Ricardo was affectionately known as "Papa Dickies," and he would sit on his front porch and watch the happenings in the neighborhood. Each year on his birthday, the entire family and all of the neighbors would gather in front of his house to sing "Las Mananitas" to this well-loved man. When Ricardo turned 100, he had 125 great-grandchildren and 29 great-great grandchildren. He died six months after his centennial celebration. (Above, courtesy of C. Senteno; below, courtesy of O. Escobedo.)

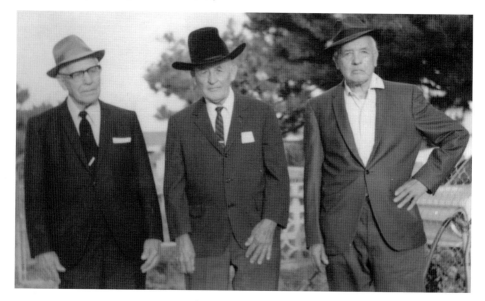

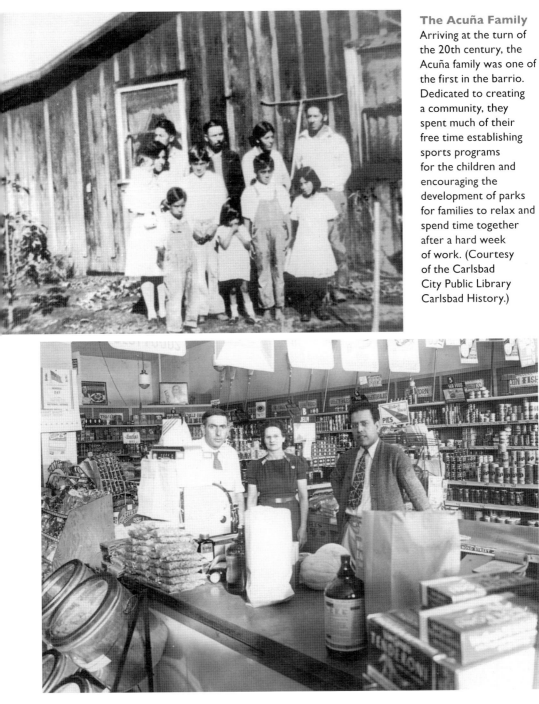

The Acuña Family
Arriving at the turn of the 20th century, the Acuña family was one of the first in the barrio. Dedicated to creating a community, they spent much of their free time establishing sports programs for the children and encouraging the development of parks for families to relax and spend time together after a hard week of work. (Courtesy of the Carlsbad City Public Library Carlsbad History.)

The Aguilar Family
With a true entrepreneurial spirit for the future of their family, the Aguilars, upon arriving in the barrio in the early 1900s, opened the Red and White Market in the Killian Building on State Street. It did not take too long before the family was able to purchase the large two-story building, where their store remained on the first floor. (Courtesy of the Carlsbad City Public Library Carlsbad History.)

Robert Kelly

Robert Kelly became half-owner of Agua Hedionda ranch with Francis Hinton. They raised horses and cattle on their ranch, and when his business partner died in 1870, Kelly inherited Hinton's half of the property. Robert Kelly remained a bachelor throughout his life and was known as one of the public-spirited men who contributed liberally in every movement. He helped to bring the railroad by donating 40 acres to the city and right-of-way passage through his ranch. (Courtesy of the Carlsbad City Public Library Carlsbad History.)

Matthew Kelly

Having fallen in love with the area when passing through at the end of the Mexican Revolution, and the first Kelly to view the beauty of Carlsbad, Matthew Kelly purchased land and named his ranch Los Kiotes. His brother Robert's ranchero was not too far from him. (Courtesy of the Carlsbad City Public Library Carlsbad History.)

William Sherman Kelly and Lavinia Jane Squires

William Sherman Kelly and Lavinia Jane Squires were the last of the heirs of Juan Maria Marron II. At the time of William's death in 1950 at the age of 85, his holdings were settled by his son Allan and were originally part of the Marron grant, consisting of 820 acres at the top of Agua Hedionda Lagoon. (Courtesy of Carlsbad Historical Society.)

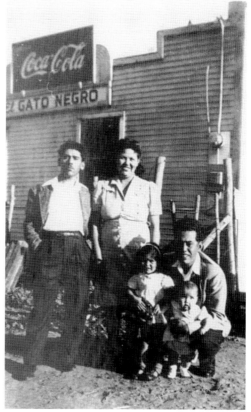

The Alcaraz Family

There was only one restaurant in the barrio in the mid-19th century, El Gato Negro, and it was owned by the Alcaraz family. Pictured here from left to right are Catarino Amador, Elvira Herrera, Linda and Virginia (their daughters), and Elvira's brother. (Courtesy of the Carlsbad City Public Library Carlsbad History.)

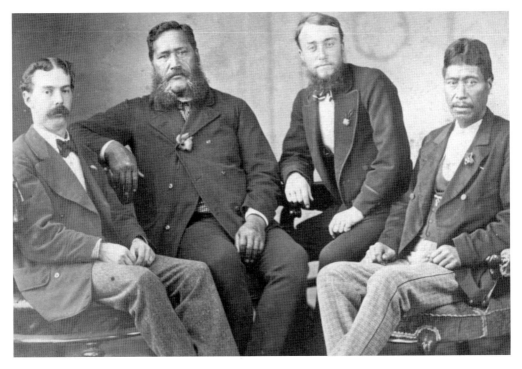

Alexander Shipley

Alexander Shipley retired as a foreign-service diplomat and decided that he would like to live in a milder coastal climate for health reasons. Bringing with him his wife, Julia, and their daughter, Florence, he chose Carlsbad to live out his retirement and purchased a home from Samuel Church Smith. The wraparound front porch had an unobstructed view of the Pacific Ocean. Shipley is pictured here with local Native American Indians. (Courtesy of Carlsbad Historical Society.)

Florence Shipley

Daughter of Alexander and Julia Shipley, Florence was an only child. As a young adult, she married Hugh Magee, but when her husband died suddenly she decided to relocate to her parents' home, where she lived until her death in the 1970s. Florence graciously left the family home and surrounding property to the city of Carlsbad to be turned in a historical museum and park. (Courtesy of Carlsbad Historical Society.)

Roy Chase

Arriving in Carlsbad in 1915 as the new station agent for the Santa Fe Railroad, Roy Chase became very well known when his job duties expanded into Carlsbad's first postmaster. Actively involved in the community, Chase became the first president of the Carlsbad Chamber of Commerce and his wife, Idella, was a charter member of the Women's Club. Their grandson Lewis Chase became a city councilman and a staunch supporter of Little League Baseball. The Chase baseball fields are named in honor of Lewis Chase for his support of expansion of the sport in Carlsbad. (Above, courtesy of the Carlsbad City Public Library Carlsbad History; below, photograph by the author.)

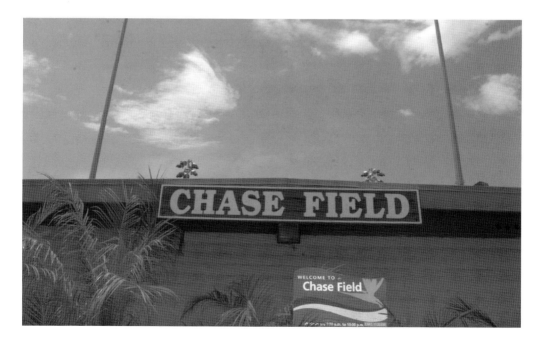

Francisca and Patricio Prieto

Francisca, who married Patricio Prieto, was one of Ricardo Martinez's daughters from his first wife. Encouraged to join her father in Carlsbad, the Prietos moved to the barrio in 1941. Initially doing field work but ultimately opening a restaurant attached to the pool hall, the Prietos purchased a lot with small houses on it. Patricio began to sketch plans for a house on a brown paper bag, pulled permits, and built it himself with the trade skills of his friends. His oldest daughter, Crespina, lives there today. The Prieto family had four daughters and one son. Sadly, their son Lalo (Edward) drowned at the beach at age 14. (Courtesy of the Senteno family.)

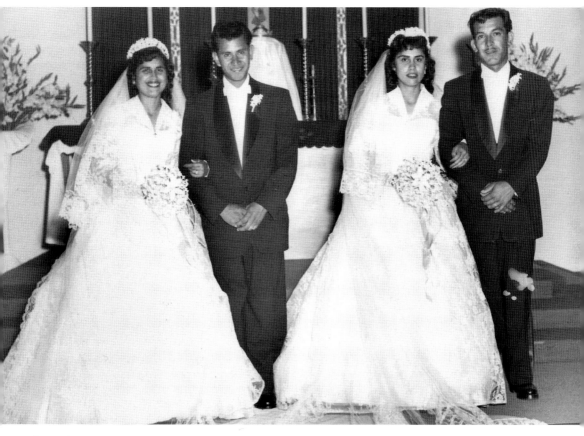

Crespina and Alfonso Senteno
Carrying on the tradition her father started, the Martinez-Senteno home remained the gathering place in the barrio for family and friends. Crespina married Alfonso Senteno (couple on the right) and had five boys. They created a large covered patio on the back of the house, which her father built, and held multiple parties celebrating all forms of milestones and holidays. There would be musicians playing into the early hours of the next morning, dancing, singing, and eating, and the children stayed up and watched from a short distance. The Senteno home was the place to go on Sundays as well. Crespina always made tacos on Sunday. Today, their friends stop by on Friday nights and listen to music and enjoy a beer at their side yard, affectionately referred to as the Cantina. (Courtesy of the Senteno family.)

John Frazier

Choosing to settle in the area in 1883, John Frazier began to dig a well for his personal water source—the rest is history. Careful analysis of the 400-foot well showed that the water was nearly identical to that found in Karlsbad, Bohemia. Many felt the water had healing powers, which inspired the development of the Carlsbad Land and Water Company. (Courtesy of the Carlsbad City Public Library Carlsbad History.)

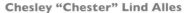

Chesley "Chester" Lind Alles

Alles Antiques was owned by one of Carlsbad's original patriarchs, Chesley "Chester" Lind Alles. Chester was married to Jennifer Powers, and they had two children, a son, Fred, and daughter, Clara. Chester loved to watch local baseball teams compete in the evenings after work. It would not be an unusual siting to witness Chester sitting in the bleachers every evening—the best heckler in town. (Courtesy of Carlsbad Historical Society.)

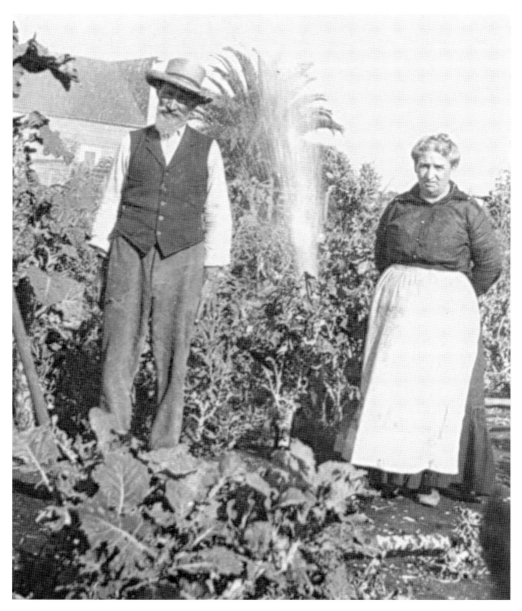

Charles Kreutzcamp
Charles Kreutzcamp was born in Germany in 1898. He was a shoemaker by trade but quickly followed his dream of coming to America. He married his wife in the United States, and they had nine children. Searching for an opportunity to build a home and business, the Kreutzcamps rolled into Carlsbad, much to his advantage, during a dip in the economy. Eventually, Charles opened a general store, and in 1904 he took over the duties as the town postmaster. A successful and dedicated citizen, Charles donated land on Harding Street in 1926 for the construction of St. Patrick's Catholic Church. (Courtesy of the Carlsbad City Public Library Carlsbad History.)

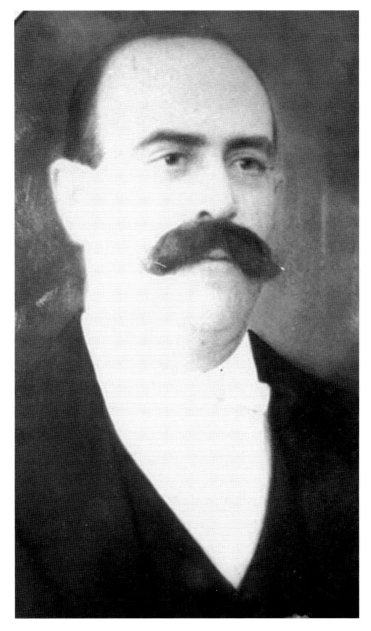

Juan Maria Marron II

An extremely large portion of Carlsbad was once known as Rancho San Francisco. It was originally a fraction of a 13,000-acre land grant awarded to Juan Maria Marron II. Marron renamed the land Rancho Agua Hedionda in 1844. A survivor of the Mexican Revolution and Indian attacks, Marron built a three-room adobe hacienda on his ranch, which still stands today. He successfully built up a herd of cattle and horses and by 1845 was appointed mayordomo of the Mission San Luis Rey lands. Marron received an unusually high annual salary of $300 for this appointed position. His daughter Maria Luz married Jose Maria Estudillo, and they had a one son, Sylvester. Sadly, when Marron died in 1853, his family found it economically necessary to section off and sell much of the land. (Courtesy of the Carlsbad City Public Library Carlsbad History.)

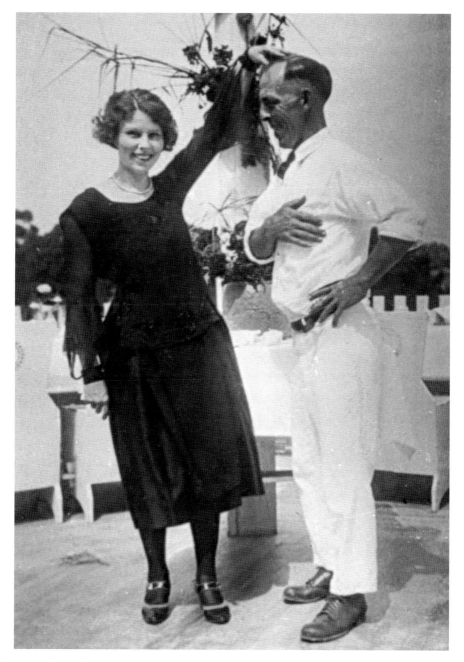

Eddie and Neva Kentner
Second owners of the original Twin Inns, Eddie and Neva Kentner purchased the business in 1919. They made a home upstairs and turned the main floor into a well known and very popular chicken restaurant. They would pack boxed lunches for hungry travelers who briefly stopped at the train station. There was also an eat-in dining room. The Kentners raised all of the chickens themselves until the mid-1950s. The Twin Inns is famous for having ghosts living in the attic. The Kentners' daughters reported hearing a man walking with a cane and a woman's voice calling for someone. (Courtesy of the Carlsbad City Public Library Carlsbad History.)

Luther Gage

Credited with introducing ranunculus to North America and putting Carlsbad on the map of the flower industry, Luther Gage decided at a young age to have a career as a nurseryman in the flower industry. Moving to Carlsbad in 1921, Gage purchased five acres at Tamarack Avenue and Jefferson Street and began to develop new strains of freesias and anemones. This then developed into varying colors of gladioli and the town's famous ranunculus. One of Gage's workers, Frank Frazee, quickly became an expert in ranunculus. His wife, Olive, was active in the community as well and a charter member of Carlsbad Community Church. She volunteered to teach Sunday school while Luther ran a men's Bible study. (Courtesy of the Flower Fields at Carlsbad Ranch.)

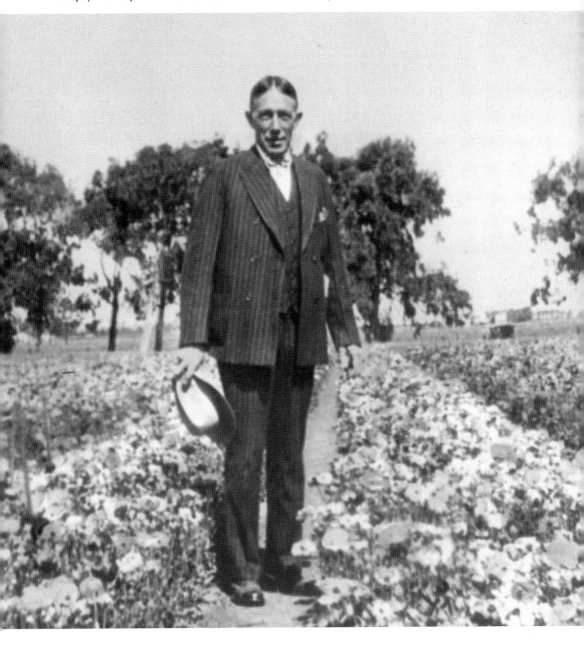

Charles Ledgerwood

Famously known by locals as the Seedman, Charles Ledgerwood was a graduate of UC Davis, then an agricultural school, and upon graduation he researched and bred tomatoes for Del Monte. Moving to Carlsbad in 1933, Ledgerwood purchased 64 acres and opened his seed business and farm, Reliable Seeds. It was located on the corner of Redwood Avenue and Highway 101, now known as Carlsbad Boulevard. Most are unaware that Ledgerwood had a passion for photography and enrolled in a class in the mid-1950s. From there his interest expanded, and he started to create films, many of which won San Diego County competitions. Ledgerwood found his way into local politics and served on the city council from 1956 to 1958 and as mayor of Carlsbad from 1958 to 1960. Once he retired, he was simply known as the Seedman. (Courtesy of the Carlsbad Historical Society.)

D.D. Wadsworth

One of the original partners of the Carlsbad Land and Water Company, D.D. Wadsworth became a fan of the home of Gerhard Schutte. Using nearly identical architectural plans, Wadsworth had his home built on the adjoining lot to look much the same as Gerhard's. This was the beginning of the local Twin Inns. (Courtesy of the Carlsbad City Public Library Carlsbad History.)

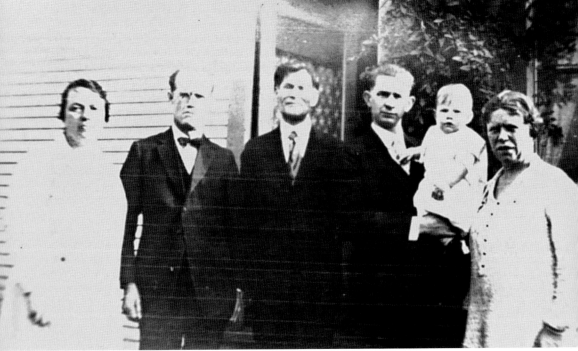

The Spences and the Henleys

Pictured here are two pioneering couples that were instrumental in the cultural preservation of the barrio. To the left are James and Marjorie Spence, Methodist missionaries who established Metodista Iglesia, and to the right are John and Ruth Henley, who were passionate about rebuilding the barrio. (Courtesy of the Carlsbad City Public Library Carlsbad History.)

CHAPTER TWO

Baby Boomers to Gen X

With the stage set by their forefathers and their line of descendants carrying on family traditions, the town and its people gained momentum. Business ventures were added, streets began to be paved, and more families moved to town at the urging of their friends and relatives. Sports teams, parks, and clubs were developed, and new programs were offered. The underlying need for an established city government became apparent, and the first mayor was chosen. With that came a period of growth and excitement for future possibilities. And then, Oceanside wanted to claim Carlsbad as part of their city plan for expansion. It was time to declare independence through the incorporation of the town. With tremendous enthusiasm and creative politicking, the local leaders rallied and began to educate its citizens. After all, Carlsbad's forefathers built the town based on their newly found freedoms and independence—anything else would be an insult to them. On June 24, 1952, Carlsbad took a vote and made the decision to become incorporated, swiftly dodging a bullet of annexation by Oceanside. It took more than 75 years, since John Frazier's arrival in the 1880s, but with great tenacity by the citizens of this town, independence was achieved.

Dewey McClellan, husband of DeeDee Chase, who was from another prominent family, became the first mayor of the newly incorporated city of Carlsbad in 1952. He previously served as president for the chamber from 1932 to 1946. A descendant of a long line of politically conscious family members, the tradition continued in Dewey's family as son Gerald and grandson Jayce followed in the family tradition and served in the position of president of the Chamber of Carlsbad.

With newfound leadership and pride of independence, the downtown area continued to grow with newly founded businesses to serve the public. Ranches on the outskirts of town continued to prosper, and new residents arrived. This was the generation of success in the flower industry and agriculture in general. The new public library, additional places of worship, and an official police force and fire department were also created. Carlsbad was finally a city that others could model themselves after.

El Bimbo

El Bimbo was a pet chimpanzee with a very strong will. Owned by a local marine who was deployed during World War II, his girlfriend Maggie assumed the care of his beloved pet. Every morning, Bimbo would rattle his cage and squawk loudly until Maggie released him in frustration. Bimbo would then run free through the barrio. The chimp ran down Taylor Street to Maggie's aunt and uncle, who made tortillas daily. Bimbo loved tortillas. He would then aggressively terrorize the neighborhood. Legend in the barrio has it that Bimbo disappeared suddenly and is buried inside a retaining wall in a backyard. Today, the retaining wall still stands, nondescript, with presumably a very dark secret hidden inside. (This image is a likeness to El Bimbo, as no photographs of the chimpanzee are left in existence.) (Author's collection.)

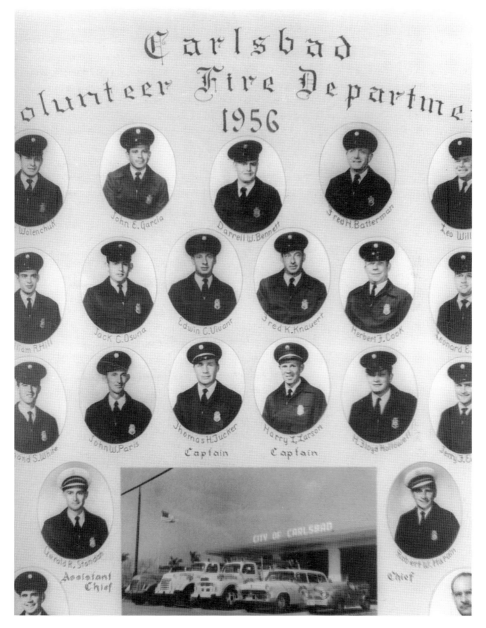

Volunteer Fire Department

Carlsbad's first volunteer fire department began in 1952. Without their own building, members met at the state forestry fire station, which was located on the corner of Carlsbad Boulevard and Beech Avenue. The volunteers were trained by the California State Forestry firefighters. To finance the new department, the men organized dances and barbecues to raise funds for their badly needed equipment. Because of the efforts of the volunteer fire department, Carlsbad's insurance rates were the same as cities that had full-time fire departments. Volunteer firemen Bob Hardin was Carlsbad's first fire chief in 1955, overseeing a budget of $27,000 and 21 volunteer firemen. Pictured here are the original volunteers with an inset of their vehicles from the 1960s. (Courtesy of the Carlsbad City Public Library Carlsbad History.)

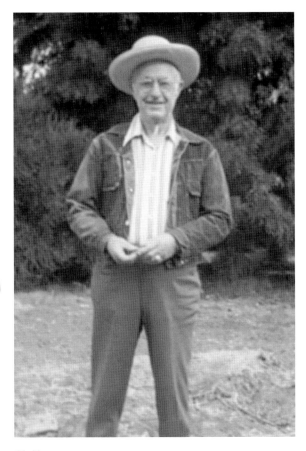

Allan Kelly

Allan Kelly was born in 1900. The grandson of Matthew and Emily Kelly, homesteaders of Los Kiotes, known today as Carrillo Ranch, Allan was the grand-nephew to Robert Kelly. Allan became a rancher but dabbled in business, joining several boards and actively volunteering for many Carlsbad community organizations. In addition to writing several books, Allan was also known for his civic duties, earning him the nickname "Renaissance Kelly." (Both, courtesy of the Carlsbad City Public Library Carlsbad History.)

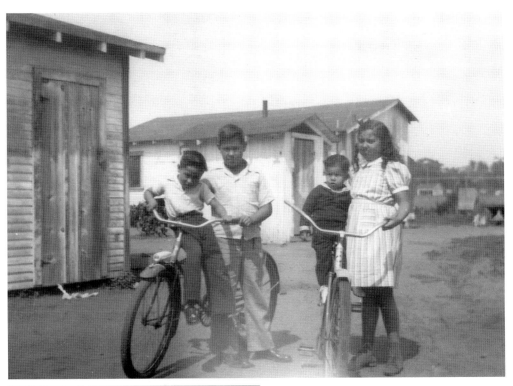

Billy Dominguez

From the Gastelum family line, Billy Dominguez is a second-generation resident. Billy's favorite memories of living in the barrio are spending time with his 22 cousins, going to the beach, and visiting his grandmother on Roosevelt Street. His grandmother was from Sonora, Mexico, where they traditionally made extra-large tortillas daily, which he would eat on his way to the beach. As a young man, he acquired his barber license and his own shop to support his future education. After graduating college, he was appointed by Governor Deukmejian as the assistant to the Department of Social Services. Billy also worked as a liaison between California and Mexico in the trans-border affairs office and served as planning commissioner for the city of Carlsbad for more than 17 years. Asked to run for elected office, Billy preferred to stay involved in the community as a local activist. (Courtesy of the Dominguez family.)

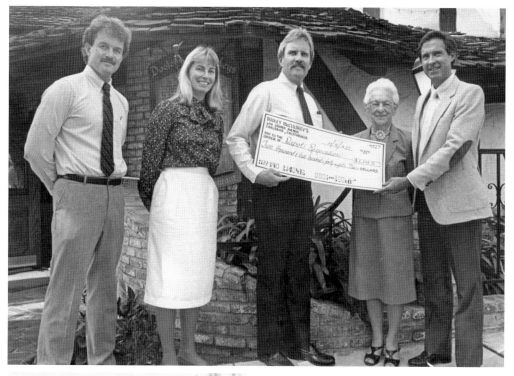

Geoff Armour

Pictured here in 1985 is Geoff Armour (far right), Carlsbad's assistant library director and treasurer of the Carlsbad Historical Society. Armour is standing next to Kay Christiansen, and they are accepting a large check, through a fundraising event, for the restoration of the Santa Fe Depot. It was presented by, from left to right, Marshall Moss, Sande Holst, and Steve Densham. (Courtesy of the Carlsbad City Public Library Carlsbad History.)

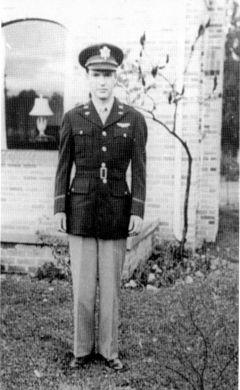

Maxton Brown Jr.

Lt. Maxton Brown Jr. was an avid bird-watcher. When Buena Vista lagoon temporarily dried up, Maxton turned his efforts to counting birds. Because of Maxton, hunting eventually took a backseat to bird-watching in the area. Sadly, Maxton was killed in Africa during World War II, but the town honors his memory with a park named after him on the fringe of the lagoon at State and Laguna Streets. (Courtesy of the Carlsbad City Public Library Carlsbad History.)

Ralph Walton

At the conclusion of his service in World War II, Ralph Walton moved to Carlsbad to be close to his parents and shortly thereafter got married. The Waltons became active members of Carlsbad Union Church, and Ralph served as a trustee of the Carlsbad Union Elementary School district for five years, three of which he was president. Ralph's true commitment was to the Boy Scouts and the Sea Scouts, representing the San Luis Rey District, which included Carlsbad, for 50 years. Holding a variety of positions of authority, Ralph was also San Diego County Council's Scout commissioner. In 1959, he received the Silver Beaver Award, the highest honor the county council gives. When Ralph's pastor spoke of him, Reverend Brokenshire stated, "A lot of people look for a halo around people's head . . . but Ralph's halo is around his heart." (Courtesy of the Carlsbad City Public Library Carlsbad History.)

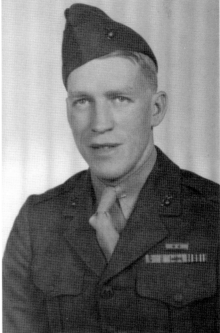

Manuel Castorena

Manuel Castorena (far right), proud of his Mexican heritage, came to the United States as a child around 1910 during the Mexican Revolution. It was a matter of safety for his family to leave, as his father was the federal government's secretary of communications, his uncle was a captain in law enforcement, and his grandfather was the inspector of schools. Ultimately, they were targets of the new political regime, so they departed quickly. Coming from a very motivated and successful family, it was not surprising to find Manuel following in the footsteps of his family members, and he become involved in his new community of Carlsbad. By 1939, he owned a grocery store at the corner of Roosevelt Street and Walnut Avenue, which he sold during World War II. After the war ended, Manuel purchased an avocado orchard at Highland Drive and Pine Avenue, and by 1950 he had saved enough money to fulfill his lifelong dream and opened a stationery business at State Street and Carlsbad Village Drive. As a local businessman, it was a natural transition to become involved in local politics, and Manuel was elected as one of the five members of the city council. His first assignment was to organize and implement the fire and police departments for the city. He is also credited with forming the Mexican American Association, a social and service club. Manuel was involved with multiple other clubs and organizations, taught Spanish at St. Michael's Church, and was a member of the Hi-Noon Rotary with perfect attendance for over 44 years. He is credited with creating 20 Rotary Clubs in a 20-year span. However, perhaps his most memorable claim to fame would be serving as the first Hispanic mayor of the town that he contributed to and loved so much. He personally went from door to door in the barrio, encouraging its residents to get out and vote. While this was an important action that helped him to win his bid for mayor, more importantly it demonstrated to the families in the barrio that they had a voice, which Manuel had taught them how to use. (Courtesy of the Carlsbad City Public Library Carlsbad History.)

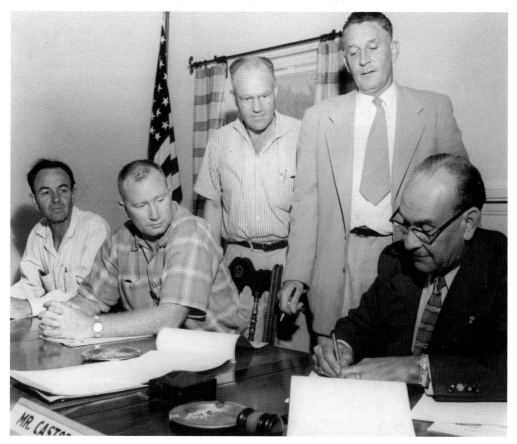

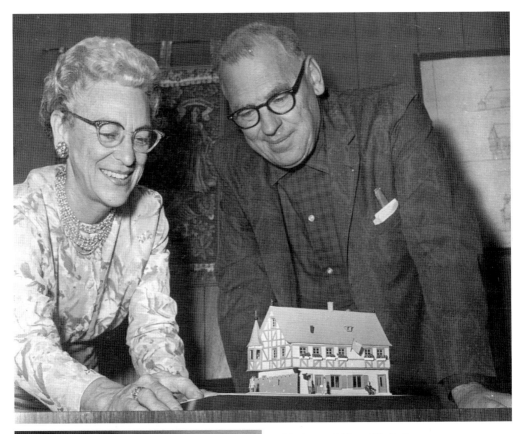

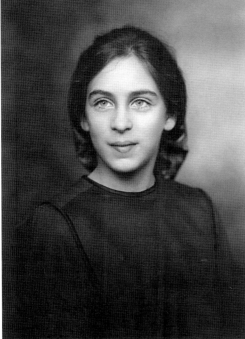

Chris and Kay Christiansen

Chris and Kay Christiansen were active participants in the preservation of Carlsbad's history. Chris founded the Carlsbad Historical Society in 1975, and both he and his wife, Kay, were the society's first copresidents. The two were a very influential team around Carlsbad, garnering donations of buildings, documents, and finances to preserve the history that surrounds us. When Kay (left) found herself widowed, she decided to continue with her dream of reopening Frazier's Well. Kay was instrumental in raising funds to commission a statue of John Frazier, which is proudly placed at Alt Karlsbad today. (Courtesy of the Carlsbad City Public Library Carlsbad History.)

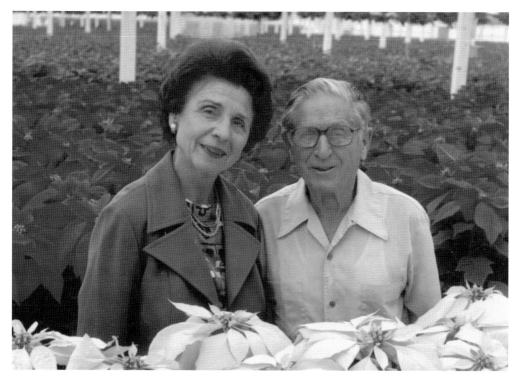

Paul Ecke Sr.

The Ecke story began when the family arrived from Germany in 1909. Paul's father started a flower business shipping dormant poinsettias around the United States, but by 1919, his father passed away. This is when Paul Ecke Sr. (above) took over the family business, and it began to truly develop. Today, the Eckes are most popularly known for their innovative breeding of the famous Christmas flower. However, the poinsettia plant was not their only botanical venture. The Eckes have also owned the Flower Fields and land since the 1960s. The nearly 50 acres, which only bloom six to eight weeks each year, have become part of a popular tradition. The entire community looks forward to seeing the burst of color coming to life, including a depiction of the American flag. (Both, courtesy of the Ecke family.)

Paul Ecke Jr.
In 1963, Paul Ecke Jr. (right and below) joined his father's floriculture business. This is when the ranch began to produce its first commercial-quality plants, which grew best as potted plants. It was through the third generation of Eckes that the vision began to shift in their commercial growing operations, utilizing the capability of a year-round greenhouse. The "Poinsettia King," Paul Ecke Sr., died in 1991, but Paul Ecke Jr. continued the family business with his son Paul Ecke III. Tragically, in 2012, Paul Ecke III had to make the hardest decision of his life—he sold the family ranch. (Both, courtesy of the Ecke family.)

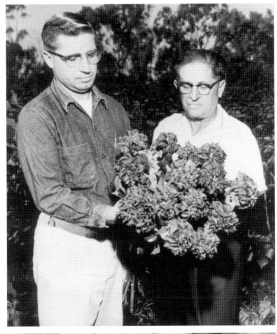

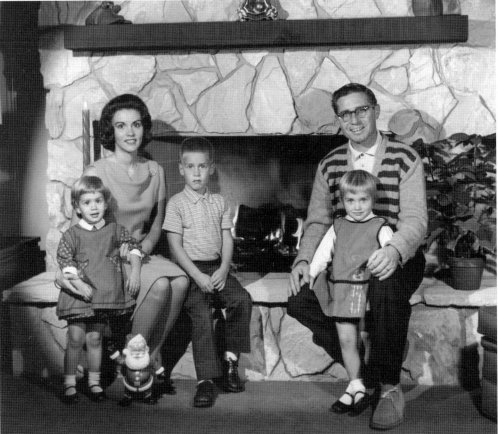

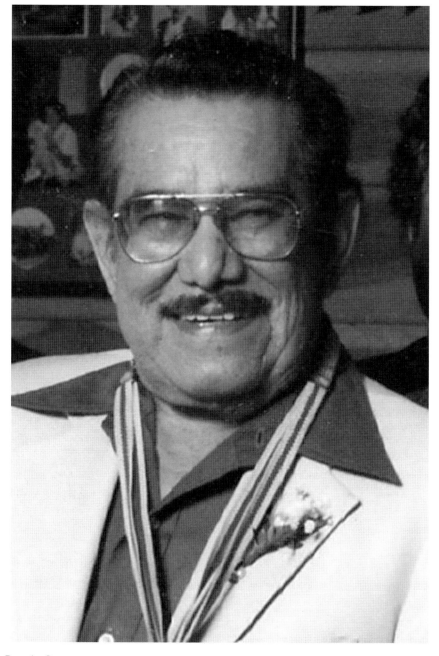

Abel Garcia Sr.
With an entrepreneurial spirit and family to provide for, Abel began cutting hair in 1938 on Third Street in Oceanside. By 1959, he moved his barber business to Carlsbad and became a bit of a real estate tycoon. Over the course of time, he managed to purchase three buildings on State Street in the heart of the village, one next to the other. While all of the buildings used to be under the ownership of one man, they have since been divided into separate properties and remain in the family to this day. The first store was turned into Garcia's barbershop, and then next door Abel started Garcia's Mexican Restaurant the same year. Today, it is run by his granddaughter. (Courtesy of the Garcia family.)

Abel Garcia Jr.

Abel Jr. earned his barber license at age 16 while in high school. After graduation, Abel joined his dad. Influenced by his father's collection of real estate, Abel purchased the old city planning building just north of the shop. Today it is Garcia's Hair Design, run by his daughter Yvonne. A huge fan of USC, Abel Jr. is the bashful Garcia.

Abel Lawrence Garcia

Abel Lawrence Garcia is a third-generation barber and began his career in 1986, but not before some family controversy. Lawrence told his grandfather that he wanted to go to seminary to become a priest, but his grandfather refused. When the priest asked why, he replied, "He's going to work with me." Today, Lawrence carries on the Garcia tradition: "My job is to take the weight of the world off their shoulders while they sit in my chair."

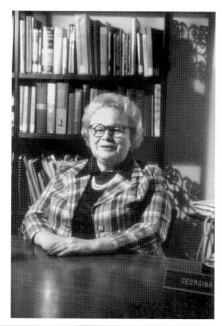

Georgina Cole

Carlsbad started a lending library in 1916 inside the general store. By 1967, the city determined that it was time to build a lending library, books were collected and Georgina Cole was named the city's first library director. Leo Pacheco, friends with Georgina's son Richard, credits Georgina with taking him under her wing and showing him the world through books. (Courtesy of the Carlsbad City Public Library Carlsbad History.)

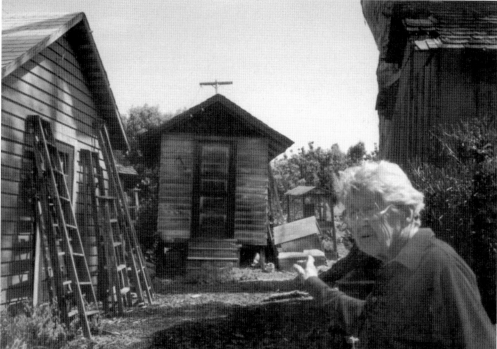

Betty Ramsay

The daughter of Frederick and Edith Ramsay, Betty lived in the family home her entire life. She was a passionate gardener and every Christmas provided flowers and garlands to St. Michael's Church. Edith's parents were very successful in the community, and Frederick constructed an entire block of commercial buildings. Her parents donated the land for St. Michael's Church, and Anthony, Betty's brother, built the church. (Courtesy of the Carlsbad City Public Library Carlsbad History.)

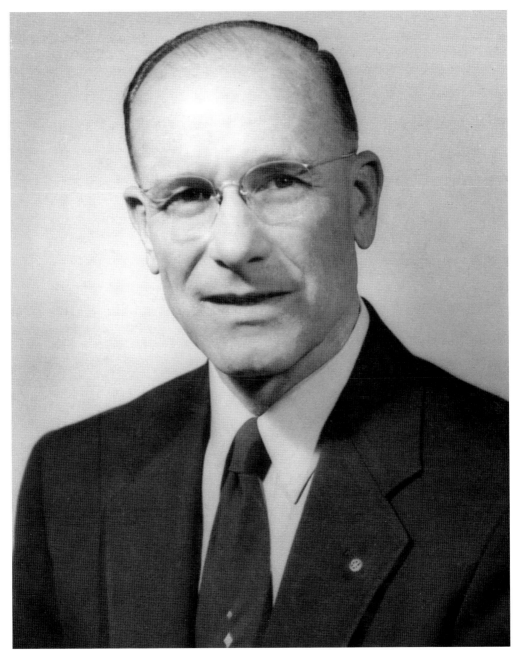

Dewey McClellan
Dewey McClellan married Dolores "Dee Dee" Chase, the daughter of Roy and Idella. Dewey immediately became a very influential resident, becoming involved with the South Coast Land Company and then later serving as president of the Carlsbad Chamber of Commerce. However, Dewey would be most famously known as Carlsbad's first mayor once the city was incorporated in 1952. The McClellans' son Gerald followed in his father's path and was instrumental in changing the name of the local airport, Palomar, to McClellan-Palomar Airport in honor of his dad. (Courtesy of the Carlsbad City Public Library Carlsbad History.)

Claud "Red" Helton

One of 10 children born into poverty, and the only one with flaming red hair, "Red" Helton eventually made his way to Carlsbad as a newlywed in 1940. He started as a plowman in a potato field, but with a driven spirit, intelligence, and ambition, Red managed to finish a correspondence course in diesel engineering and was offered a job at Camp Pendleton that led to multiple promotions. By 1947, he became a general contractor for both residential and commercial properties and formed Helton Construction on State Street. His wife, Gretchen, turned the neighboring building into a small burger stand and offered Carlsbad's first soft-serve ice cream. In the 1950s, Red was instrumental in promoting the creation of the new city of Carlsbad. He also actively campaigned to bring Colorado River water to the city. A passionate promoter of the city, Red was actively involved in multiple civic positions. (Both, courtesy of Linda Slater.)

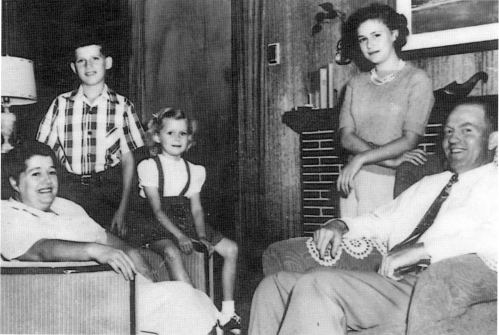

Leopoldo Antonio Carrillo

Born Leopoldo Antonio Carrillo, Leo's great-great grandfather Jose Raimundo Carrillo was one of the first to settle in California, arriving in 1769. Jose's wedding to Tomasa Ignacia Lugo was performed by Fr. Junipero Serra, and the young couple received Coronado Island as a wedding gift. Leo's legacy had already been set in stone by the time he was born in 1880. Upon graduating from college with a degree in engineering, Leo worked briefly as a cartoonist before moving to New York City to pursue an acting career. While working on Broadway, he met his future bride, Edith, and together they adopted a daughter, naming her Marie Antoinette. Throughout Leo's acting career, his work flourished with 90 motion pictures, 15 major stage plays, and his most famous role, Poncho in the first television series filmed in color, *Cisco Kid*, in the early 1950s. Throughout his life, Leo learned to speak five languages, which perfected his ability to imitate accents, managed Earl Warren's campaign for governor, was appointed to the California Beaches and Parks Commission on which he served for 18 years, became goodwill ambassador for California to promote the state to other countries, and befriended two sitting presidents, Eisenhower and Nixon. Falling in love with the area, Carrillo decided to create a respite away from the hustle of Hollywood and purchased property in Carlsbad to create his 600-plus acre cattle ranch, on the land that was once Juan Marron's and then belonged to the Kellys. Leo fixed up the old adobe that was on the property and added various other out buildings; he successfully created a peaceful place where he frequently entertained some of the biggest stars of his era. Leo loved his Castilian Spanish heritage and used Hollywood to regain the prestige of Californios that had been lost over time. The ultimate goal in purchasing the ranch was to reclaim his family heritage and the lifestyle that so commonly was identified with a ranchero. He was inspired to preserve all of his great-great grandfather's ideals. Today, the ranch is on the National Park registry and on the California Historic Park registry. (Courtesy of the Academy of Motion Pictures Arts and Sciences.)

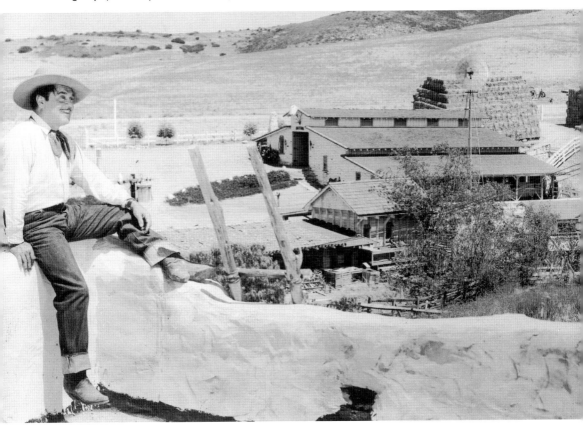

Belynn and Alfredo Gonzales

Garcia's Mexican Restaurant has been a local family-owned business serving Carlsbad since 1960. Founded by Ophelia and Abel Garcia, the business celebrates its third generation of family leadership under the guide of granddaughter Belynn R. Gonzales. Giving back to the community through a variety of organizations and charities, Garcia's embraces the idea of making a positive difference one step at a time. With family-crafted recipes, friendly service, and homestyle Mexican comfort food that is worth writing home about, Garcia's is a staple of Carlsbad Village, adding an authentic and unique flavor to the community. Belynn is pictured here with her son, Alfredo. (Courtesy of the Gonzales family.)

Emerald and Minnie Hummel
Hummel's Exotic Gardens first arrived in Carlsbad in 1952. Emerald and Minnie (Byrne) Hummel were well known for their hybrid plants of cacti and succulents. Selling their hybridized plants worldwide, the Hummels also wrote articles for publications and their own book describing their methods for hybrid plants. The results of their talents can be found today at Ohio State University, the Wild Animal Park, UC Berkeley, CA Botanic Garden, and Quail Botanical Gardens, Lotusland, Huntington Botanical Gardens, and the agriculture department at UC-Davis, which received the Hummels collection of literature and catalogs. (Both, courtesy of the Carlsbad City Public Library Carlsbad History.)

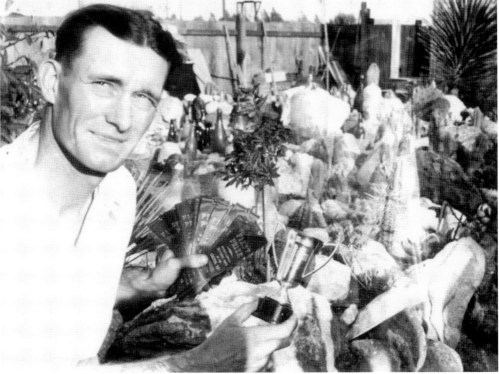

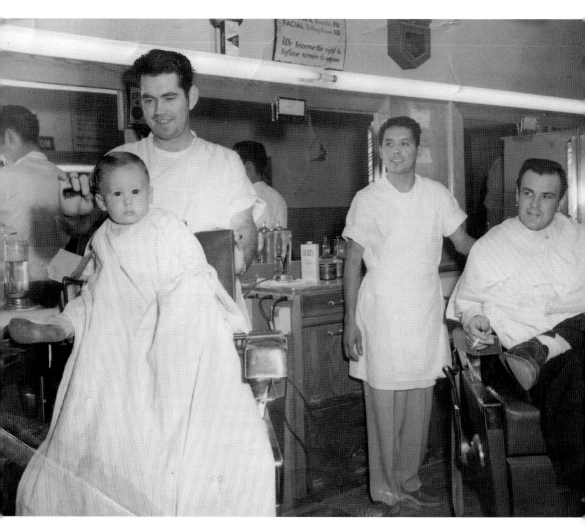

John McKaig

Johnny the barber (pictured left) was a cornerstone of Carlsbad history during the early stages of incorporation. A huge proponent of giving back to the community, John McKaig was involved with the housing appeals board, the park commission, and board of directors of the chamber of commerce and served as president of the Boys Club, Little League, Pony League, and other civic groups. He was also named man of the year in 1964 by the chamber and citizen of the year in 1972. But the unique thing about John was his profession as a barber, which he began in 1947. John was known as a very clever and humorous man. His hobby was carving tikis out of palm trees, so where there was a palm trunk available, it was given a new life with character. (Courtesy of the McKaig family.)

Johnny the Barber and Son

Johnny could always be heard calling his wife baby doll and was known by his famous saying, "Vaya con Dios!" Johnny the barber eventually closed his shop and joined Abel at Garcia's barbershop. It was while he was working at Garcia's that he helped his son John (below) get his foot into the door of barbering. Maintaining his profession as a family tradition, John started in the business in 1991. He works there today, the second generation of McKaigs with the third generation of Garcias. They have merged their families and their trade, and many who frequent the shop feel as though everyone is family. (Left, courtesy of the McKaig family.)

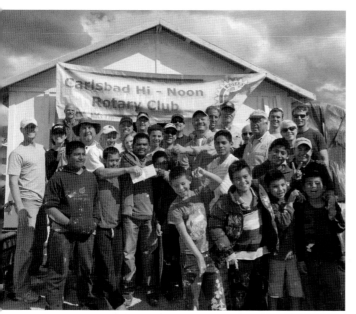

Hi-Noon Rotary

In 1939, a handful of businessmen decided to start a local Rotary Club. The club started with 21 members and had spotty attendance as a result of World War II. However, because of the founding members' perseverance and dedication, the club survived and continues today. Serving the community, specifically targeting the toughest challenges, the Rotary has many local projects for service and the youth. One of Hi-Noon's most well-known founding members was Manuel Castorena, a former mayor of Carlsbad. Locally, the Rotary is popularly known for its Oktoberfest and the Teens and Marines Golf Tournament. (Courtesy of Hi-Noon Rotary.)

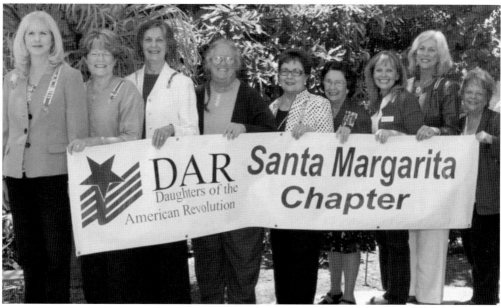

The Santa Margarita Chapter of DAR

The Daughters of the American Revolution (DAR) is a nonprofit nonpolitical volunteer service organization serving all 50 states. The Santa Margarita Chapter of the NSDAR, chartered in 1929, serves Carlsbad, Oceanside, Vista, and San Marcos. Members must research their family lineage and prove through ancestry documentation that they, in fact, had a family member participate in the American Revolution. The DAR promotes historic preservation, education, and patriotism. There are four active members from Carlsbad that are on the board of the local chapter. Pictured from left to right are unidentified, Charla Boodry (vice president), Mary Catherine Kirby (vice president), unidentified, Sue Stehle (recording secretary), two unidentified women, Jacqueline Berzins (registrar), and unidentified. (Courtesy of the Santa Margarita Chapter of DAR.)

CHAPTER THREE

It Was Their Destiny

Quickly, things began to develop on the next level in Carlsbad. A true visionary typically has an unusually keen foresight into a situation that can be improved, created, invented, or implemented. There are two distinct groups within this category, the nonprofit and the for-profit business venture. Palomar Airport was built, leading the way. Followed by outdoor sports with the first skate park and nationally recognized raceway. With great anticipation, LEGOLAND arrived, and the pattern of growth continued. Lauded as the golf capital of the world for corporate headquarters, TaylorMade-Adidas Golf Company, Callaway Golf Company, and Cobra Golf have found a place in Carlsbad's clean industry business park. Upper Deck baseball prints cards in town, and many popular clothing and shoe lines, such as No Fear and Atticus Clothing, do their artistic brainstorming locally. Groups that research biotechnology and computer and video game development are nestled within athletic fields and gourmet food courts in well designed and aesthetically pleasing architecture. There are many successful local businesses in the cottage industry that have become household names because of their owners' commitment to the community. Local activism for a variety of organizations and causes also flourish in the seaside community. With heavy support by both volunteers and donors, the growth of reaching out and lending a hand has become second nature for many. Whether it is local or international, there is representation of all parts of the world by Carlsbad residents, who maintain a common philosophy: "Let's make the world a better place."

To have a dream that one can turn into a reality is what the people in this chapter represent: the establishment of forward-thinking organizations, enhancing green education, or creatively beautifying the city. Also included are individuals who saw a need and determined a way to educate and provide. The idea to hand out a simple pair of shoes to a needy child, diabetes awareness for youth, or recognizing a need for local military and then unselfishly fulfilling it, Carlsbad is filled with selfless individuals who continually think of others before themselves. But just as important are the members of the community who creatively opened a unique business that has established itself as a local icon. These are the individuals who so generously give to the organizations that survive on pure donations. This is a good marriage. It is where one committed action succeeds because of another action's recognition of being blessed. This is Carlsbad.

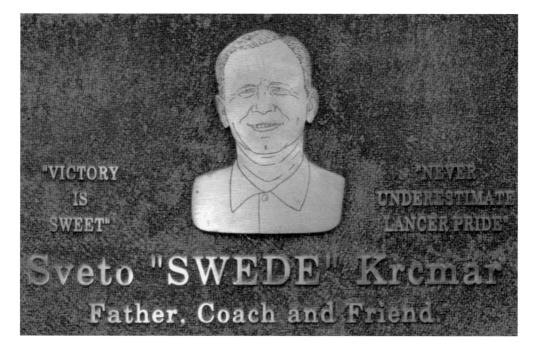

"VICTORY IS SWEET"

"NEVER UNDERESTIMATE LANCER PRIDE"

Sveto "SWEDE" Krcmar
Father, Coach and Friend.

Coach Kirchmeyer

Carlsbad High School football coach "Kremar" and his assistants Don Johnson and Buddy Lewis were instrumental to the football program from 1958 to 1971. Under Swede Kirchmeyer's leadership, his boys excelled in the game, winning three CIF (California Interscholastic Federation) championships in 1961, 1962, and 1965, a true testament to his ability to get the best from every individual he coached. For the 20 years Kremar was at Carlsbad High, he taught math, served as a counselor and athletic director, and coached golf, track, and football. Considered one of the finest coaches in San Diego County, Kirchmeyer had the unique ability to bring the community and school together, just like his teams. His high standards and ideals and emphasis on sportsmanship, personal courage, and integrity are an inspiration to all whose lives he touched. Teaching the game of life through football, CHS dedicated its football stadium to Coach Kremar.

WELCOME TO SWEDE KRCMAR FIELD HOME OF THE LANCERS

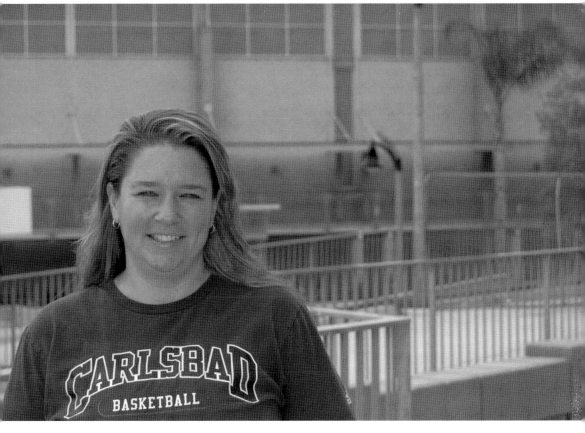

Amanda Waters

Born in Maine, Amanda Waters attended Husson University in Bangor, Maine, on a dual basketball-softball scholarship. One of her coaches, Kissy Walker, who was inducted into the Husson University Hall of Fame, was her biggest inspiration to become a teacher and ultimately, the very first female athletic director at Carlsbad High School since it first opened in 1957. Waters came to San Diego when she was drafted to play for the National Women's Basketball League. She met her husband here, and they have two children. Hired by CHS to teach physical education and business, Waters also became the girls' basketball coach from 2010 to 2014. The girls won CIF in 2014, and Waters "retired," transitioning into her position as athletic director.

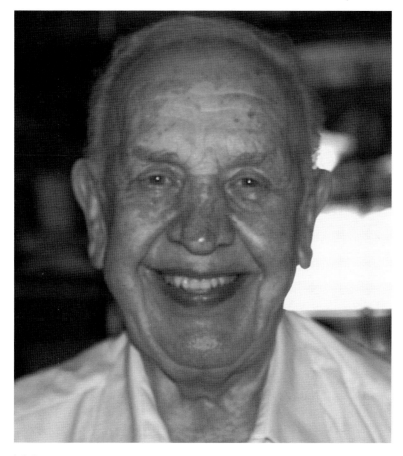

John Haedrich

Tip Top Meats is Carlsbad's old-world butcher shop with a European feel that was created and developed by "Big John." The well-known restaurant has home-style cooking, large portions, and excellent prices. John Haedrich makes sure that he purchases the highest quality meats and creates the best homemade sausages. The feel of this meat counter, deli, market, and restaurant is everything that one would imagine a specialty market in a German village might have. However, the true drawing card to this legendary establishment is the owner. Originally from East Germany and born in 1929, John was fortunate to learn his trade from his family. His paternal grandfather and father were both butchers, as was his maternal great-grandfather and on down the family line on his mother's side. As the political climate began to change in his hometown, John's father encouraged him to leave and go west stating, "If you must fight, fight for the Star-Spangled Banner." John was able to make his way to West Berlin at the young age of 20 and arrived in the United States on February 6, 1959. As a trained master butcher, John can be found behind the meat counter or in the restaurant seven days a week at the youthful age of 87. Exemplifying the true entrepreneurial spirit, John chased after the American dream—and caught it. With the most infectious personality and storytelling skills, John wakes up every morning and "thanks God for his family, for living in America, for living in Southern California, and for living in Carlsbad." He always thanks God every day for his health and maintains "4H" (happy, healthy, heart, and hands). John's success is a result of his undeniably positive attitude for life, generosity toward the community, young heart, integrity, and deep faith in God. In 1981, John had a serendipitous encounter with a 17-year-old surfer. Steve Reid walked up to John and asked him for a job. The young ponytailed man explained that he was a hard worker who only needed to be shown how to do something once. John took a chance on Steve and originally hired him as a dishwasher.

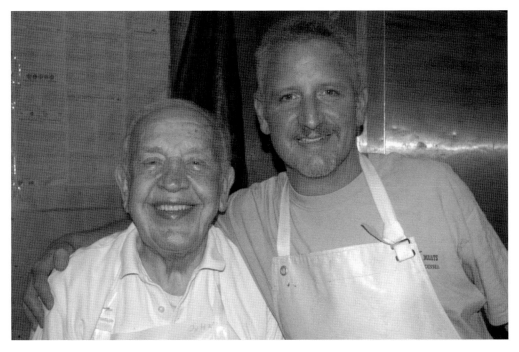

Steve Reid

Unlike John, Steve Reid is a home-grown local who grew up surfing at Cherry Street, eating at Lola's, and frequenting the Boys and Girls Club. By the time he was in his early 20s, Steve was already working behind the meat counter and saw a lucrative future as a butcher if he could just convince John that he could be trained. Taking on the young protégé, John began to teach Steve, as though he were German, with all of the skills, techniques, and old-world traditions required of a master butcher. The rest is history. The two men have become business partners and maintain the belief that their continued success is a result of consistency, honesty, and respect for one another. Steve declares that John is a fantastic mentor and he enjoys working with him every single day, which has resulted in a deep and long-lasting friendship.

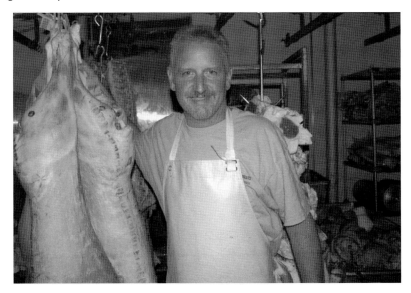

Clara Marsden

Clara was born and raised in Colombia and came to the United States to attend college. She moved to Carlsbad in the late 2000s where she become actively involved in the community and a teacher's assistant at St. Patrick's School. Clara's unique perspective on life resulted in philanthropic work helping to provide shoes for children of the poverty ridden city of Medellin, Colombia. Shoes to the World was developed and joined partnership with a Medellin-based nonprofit organization called Emiliani Project. Emiliani houses and educates orphaned children. With each $5 donation, one pair of shoes is made in Medellin, supporting the local economy, and then personally handed to each child. As of 2015, more than 6,000 shoes have been handed out, one child at a time, and the organization has expanded globally. (Courtesy of C. Marsden.)

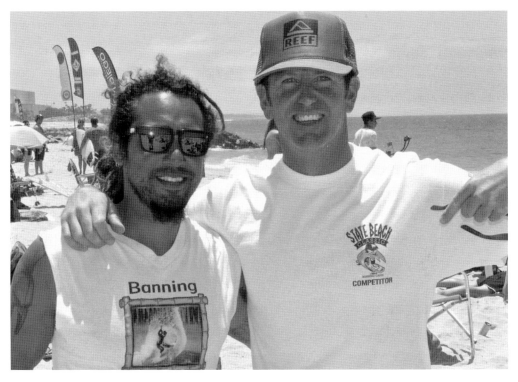

Phil Antonopoulos and Ulises Thomas
An annual surf event held in tribute of Banning Capps, one of Carlsbad's favorite sons of surf whose life was tragically cut short, helps to raise money in his honor for the Boys and Girls Club of Carlsbad. The event, locally known as the By Carlsbad Surfers for Carlsbad Surfers Event, was the brainchild of Phil Antonopoulos (right) and Ulises Thomas (left). The first event was held in 2011 and has grown each year not only in popularity but in proceeds that directly benefit the children of the community. With impressive sponsors, this family-friendly event draws local surfers to those who travel from afar for the opportunity to compete at the famed Tamarack State Beach. (Above, courtesy of P. Antonopoulos; below, courtesy of U. Thomas.)

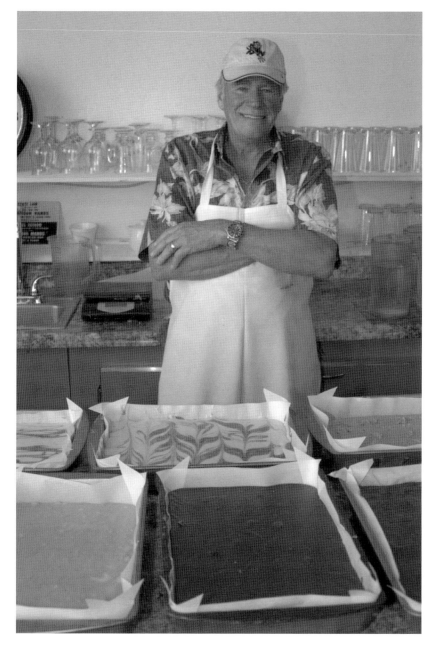

Al Wanamaker

Al Wanamaker is famous for making the best fudge in town—over 12 different flavors. His wife, Barbara, sells the fudge at the farmer's market on State Street each week, and there is always a line. Vacationing in Carlsbad more than three decades ago, Al said that he immediately felt the aloha spirit and relocated in 1986 from Hawaii. Not one to sit idle, Al opened Al's Café in the Village and joined the Rotary, serving as president from 2010 to 2011. As president, he worked with Rotary International and, at his wife's suggestion, created a program in which 100 people would pledge $100 each to purchase 100 goats for a rural area in India. A successful program, each family that received a goat, has goat's milk, and breeds them to sell for income. The program continues to strengthen every year.

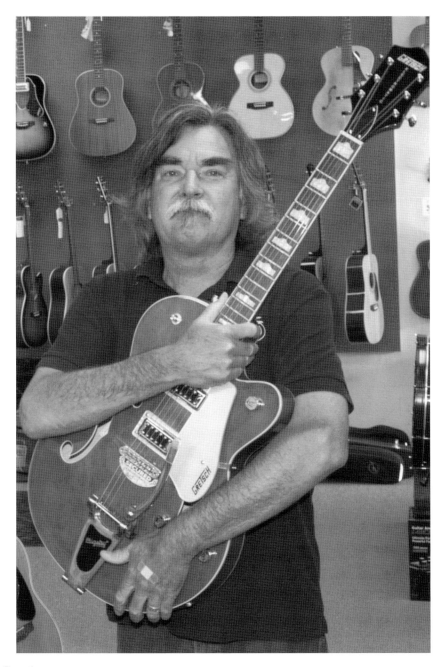

Roy Good

Giacoletti Music has been a downtown Carlsbad landmark since 1982. Music education has always been the main focus, with a full-line music store to support it. The family-owned business currently has third-generation employees and is managed by Roy Good. Good has been with Giacolettis since the year after they opened and has served on the board of directors at the Museum of Making Music in Carlsbad. Roy is now director of the music school, taking over for Beth Giacoletti, the daughter of founders Bob and Eleanor. Good not only works directly with the teachers and over 300 students to keep the music school running smoothly but also teaches and impressively plays multiple instruments himself.

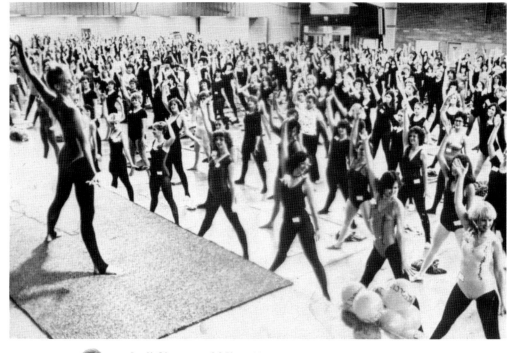

Judi Sheppard Missett

Judi Sheppard Missett started the fitness revolution that became Jazzercise in 1969. A seriously inspiring, award-winning, find-your-passion-and-live-it CEO, she runs the company and teaches classes every week. Judi's daughter Shanna Missett Nelson grew up with Jazzercise and today is also an instructor and the company president. Jazzercise has a longstanding tradition of giving back to the community, and the instructors have raised more than $28 million for a wide range of causes, most of them directly affecting Carlsbad and other local communities. Joining the fight against childhood obesity, the company also offers Kids Get Fit, which is a community outreach program. The instructors throw free dance parties at schools all over the world to inspire kids to get moving. (Both, courtesy of Jazzercise.)

Jack and Nina Baugh

Married in 1964 and five children later, Jack and Nina Baugh found themselves retired and with time to spare. Throughout their lives, they have always maintained the motto "Find a need and fill it." Actively involved at North Coast Calvary Chapel and dedicated to serving the Lord, the Baughs felt called to breathe life into a program at their church called Military Support Network (MSN). With Camp Pendleton so close and a number of military families living within the community, Jack and Nina began a new personal journey in 2005. When they took over the program there was very little money, so they set out into the community looking for volunteers, donations of food, and other tangible items, hoping to fill the needs our military might have, large or small, temporary or permanent. Meeting with a lieutenant colonel on base, they were initially allowed to adopt one battalion of men and women. A decade later, they have adopted the entire base, every battalion and multiple regiments, which hold thousands of soldiers. They hold dinners, have root-beer float and ice cream–sundae parties for family days, hold exit dinners before deployment and entrance gatherings for spouses who are anticipating their military partner's return home. All of these events are held because of the donated time, services, and food from the community, but more importantly, by Jack and Nina's orchestration. Over the last decade, MSN has grown to include donated ball gowns to military wives for their annual formal dinner dance, donated furniture, baby clothes, and many other items for young families to set up house. One of the favorites for the military is when 150 Costco pies are delivered for Thanksgiving and then again for Christmas. The largest honor imaginable came very early on for Jack and Nina. They were nominated by the Marines at Camp Pendleton to win a prestigious award. Unbeknownst to the Baughs, it was a nationwide selection, one person or couple to represent each branch of the military. In 2010, Jack and Nina were presented with the Spirit of Hope Award at the Pentagon. Receiving this award is a true testament regarding the impact that the Baughs have had on the lives of our military in Carlsbad's own backyard.

Diana Slaughter Aaron

Diana Slaughter Aaron was executive director for the Carlsbad Educational Foundation (CEF) from 2000 to 2007. It was her first job working for a nonprofit. She served as the executive producer for the foundation's telethon, a creative endeavor to raise funds for schools. On March 22, 2001, CEF produced the first telethon and raised $34,600. Just as important as the money was the opportunity to bring the community together for a common cause: education. The combination of community collaboration while raising funds for the STAR (Science, Technology, Arts, and Reading) campaign was unique and exciting. Initially it was broadcast from the Carlsbad Safety Center, but the telethon was later moved to the Carlsbad High School Gym when they became wired for live broadcasting. It was a challenge to turn the venues into a television studio, but they succeeded. The final telethon was in 2007 and raised over $100,000. The telethon was a three-hour live broadcast, giving each school its own 15 minutes of fame. Every school was showcased. The students were the stars—they were able to shine and show their talent. Students also learned that they could help raise funds for their school. According to Diana, "I love the idea of planting the seed of philanthropy early so that children know that they can make a difference in their world. If everyone does something, however big or small, what a better world we would live in." The telethon also highlighted the items that the Carlsbad Educational Foundation had donated. This was done by going to the schools and videotaping segments that were then shown during the telethon. This gave donors the ability to see their donations in action, and how what was purchased supported the students and teachers in the classroom was a powerful way to encourage other donations. The first telethon included 250 children and over 100 volunteers. In addition to the performances there were also junior hosts, students from Aviara Oaks Middle School, Valley Middle School, and Carlsbad High School. Local businesses could do a walk-on presentation of a check of $500 or more during the telethon. Any pledge amount could be called in. Lead volunteers for the telethon included Nancy Held Loucas as producer, Carleen Proctor as administrative coordinator, Wendy Johnson as volunteer coordinator, Doug Green as educational content producer, Mark Walton as celebrity emcee, and Ned Augustenborg as director. (Courtesy of D. Aaron.)

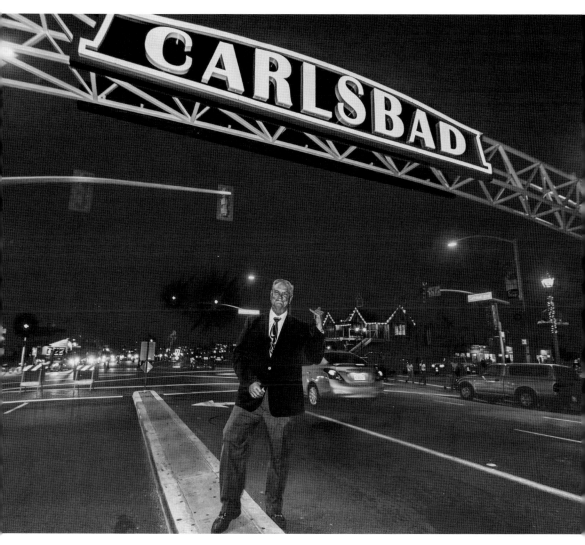

Carlton Lund

Carlton Lund has accomplished more in six short decades than what would take the average person three lifetimes to achieve. Carlton, along with his wife, Sandy, created a real estate business more than 35 years ago that maintains an excellent reputation in their field today. Carlton and Sandy received the honor of Citizens of the Year in 2007 for their extraordinary dedication to the community. What will undoubtedly be considered one of Carlton's greatest legacies is the iconic Carlsbad sign project, in which he was the driving force. In 2015, the long-awaited Carlsbad sign ceremony replaced the original historic city sign, last seen in the 1930s above Highway 101. This fulfilled a 14-year dream for many. With Carlton's accomplishments and best business practices, one will probably never meet a more kind and caring man with a truly big heart. (Courtesy of Lorenzo Menendez, *Carlsbad Magazine*.)

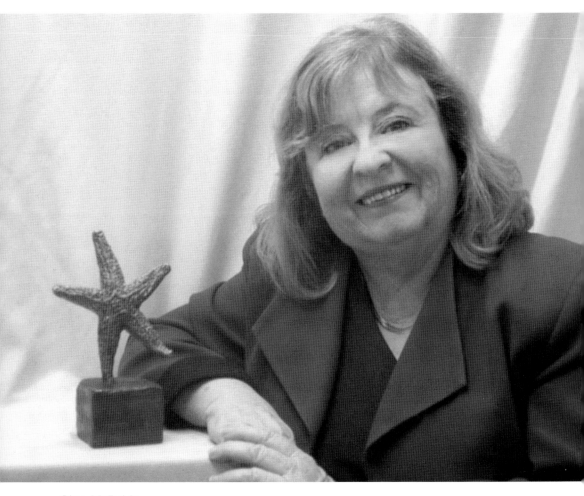

Gina McBride

Gina McBride founded the STARFISH Leadership Awards to honor those who have shown extraordinary commitments to worthwhile causes and have inspired, engaged, and led others to join in those efforts, thus making major ongoing impacts throughout their global or local communities. She published *The Starfish, Other Stories of Giving and a Collection of My Favorite Quotations*, which she personalized for STARFISH honorees and organizations. McBride also founded It's in the Bags!, a program designed to honor organizations for collecting food and personal items for those in need, including pets. She is also co-owner of Animal House Pet Care and Natural Treat Bakery with her daughter Susan. With her special interest in charitable gift planning, Gina McBride encourages others to experience that special joy that comes from giving, inspiring them to make a difference in the world—and in their lives. (Courtesy of G. McBride.)

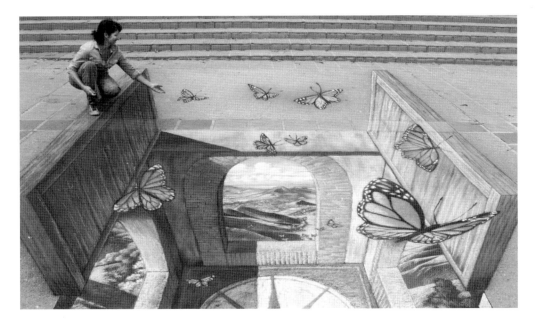

Joni Miringoff

Joni Miringoff has been part of the Flower Fields success for more than 20 years, running the school program, leading all tours during the in-bloom season, organizing weekend special events, and running Kids Day during the Flower Fields' season. Additionally, she is one of the creators of ArtSplash, which is a two-day nonprofit family event that promotes and benefits arts within the community. ArtSplash has grown, with Miringoff's help, into a community-wide partnership of organizations and businesses working together to establish an annual family event showcasing North County. It is a popular weekend activity for all residents to be able to see incredible street art, eat really great food, and listen to incredible music while looking across the Flower Fields to the Pacific Ocean. (Both, courtesy of ArtSplash.)

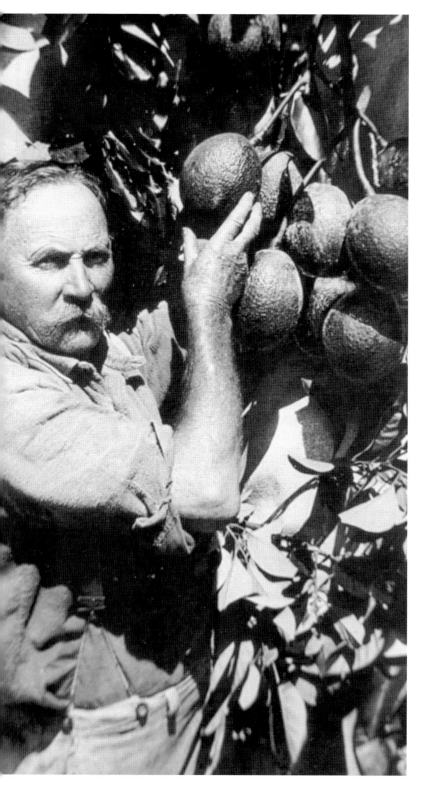

Sam Thompson
"Home of the Avocado," Carlsbad can thank Sam Thompson, veteran nurseryman, for the introduction of avocados. In 1916, Thompson planted eight acres of alligator pears on Highland Avenue. This was the grove where he experimented with cross pollination, dreaming of new and varied versions of the fruit. By 1920, avocados had become synonymous with the seaside town, and by 1923, the Carlsbad Avocado Growers Club was formed with its first 17 members. Happily showing off the fruits of his labor, this photograph of Sam Thompson was taken in one of his groves in 1928. (Courtesy of Carlsbad Historical Society.)

Russ Bruhn
One never forgets a truly awkward moment. Russ Bruhn experienced one when his youngest son, Tyler, was playing baseball in the Good Will Games. Their first match was against a team from Kauai, Hawaii, that brought the Carlsbad team lovely gift bags for each empty-handed player. After the game, Russ found himself running around downtown Carlsbad looking for anything that had the city's name emblazoned on it and came up with a big fat zero. In 2003, Russ created Carlsbad Gourmet, with a line of delicious products that were made with strawberries locally grown. Today, both of his sons, Jordan (left) and Tyler (right), work in the family-run business, developing recipes for multiple clients. The Bruhns now have 11 different barbeque sauces, seven hot sauces, many spreads, and mustards. (Courtesy of the Bruhn family.)

Anne Spindel

Most young students in Carlsbad will recognize Anne Spindel as the "Tree Lady." While a parent of elementary-aged children in 1996, Anne determined that the science curriculum could use a little encouragement and came up with the idea to hold a science fair. With zero budget but a lot of enthusiasm, donations began to appear. Anne then contacted a program called Talk About Trees (TAT)—a hands on exploration of forest materials to gain insight and understanding in basic tree physiology, identification, and the importance of trees. TAT generously donated a tiny young tree to each student to take home that first year. Science Day became a big hit and has grown over the years with new and exciting workshops. Anne now works for Talk About Trees as an education facilitator in North County. (Courtesy of A. Spindel.)

Deb Ferraro

Deb Ferraro is a Yoga Alliance registered yoga teacher (RYT) and is trained to teach yoga sculpt, vinyasa hatha flow, yin yoga, kids' yoga, cycle-yoga, barre yoga, and bootcamp-yoga. In 2012, Deb developed the collaborative effort approach of the Carlsbad Village Yoga Co-op. Through synergetic efforts, the team members work with the community to provide a platform for classes, programs, and events to take place in the heart of downtown Carlsbad Village. In 2013, Deb formed the grassroots 501(c)3 nonprofit called Carlsbad Causes for Community (C3). C3 began as a fundraising program through the yoga co-op and has since expanded into an amazing philanthropic community collaborative involving 45 Carlsbad businesses and hundreds of supporting Carlsbad residents. (Both, courtesy of Ashley Strong Photography.)

Sue Prelozni

Sue Prelozni is founder and chief executive officer of Sustainable Surplus Exchange (SSE), a 501(c)3 nonprofit organization. She manages collaborations with more than a dozen green-solution companies. Passionate about the environment, Prelozni is active in community organizations. She serves on the sustainability committee of the Carlsbad Chamber of Commerce. Participating in many sustainability and green programs, Prelozni also speaks to businesses on the importance of California Assembly Bill 341—a mandate for businesses to reduce their solid waste by 75 percent through recycling and diversion by 2020. She received the Women Who Mean Business Award from the *San Diego Business Journal* in 2014. While at the helm of Sustainable Surplus, the organization has been the deserved recipient of several innovation and green-technologies awards. (Courtesy of S. Prelozni.)

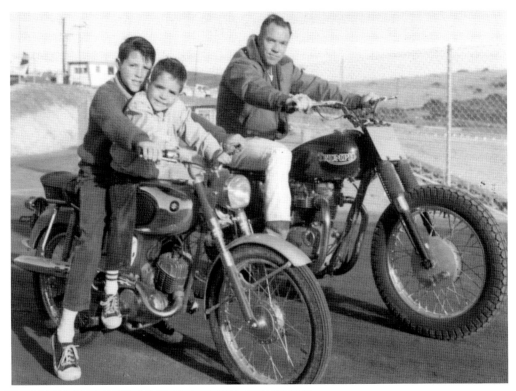

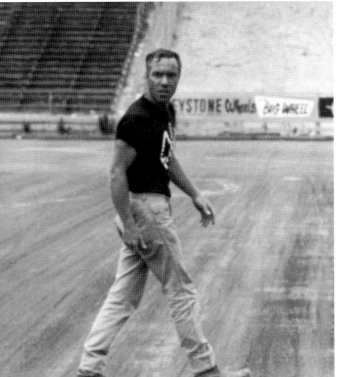

Larry Grismer

As a young man, Larry Grismer joined the Air Force and learned to fly, and upon leaving the military he became a real estate agent. Grismer's job was unique, as he sold large pieces of land from the air. On one of these flights, he noticed a large piece of land in Carlsbad and had an idea. Grismer contacted Sandy Blond, former Indianapolis racecar competitor, in 1961, and the two became business partners to purchase the land. By 1963, Carlsbad Raceway was official. Drag racing was held every weekend and then motocross was added. Shortly after, ABCWW sponsored the US Grand Prix there. Larry's sons were part of their dad's business; one worked motocross and the other the drag strip. Born in the 1930s, Larry runs two miles every day and still flies his own airplanes, a Twin 210 Cessna and a Stearman Biplane. (Both, courtesy of the Grismer family.)

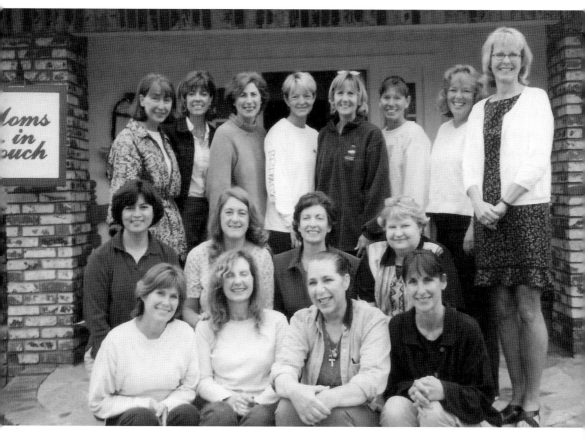

Mina Cooper

At Moms in Prayer International, they believe that a mom can be the single greatest force for good in the lives of her children and the children around her. This was the mantra that Mina Cooper lived by so she became the hostess, for decades, of Carlsbad's Moms-In-Touch. She welcomed women into her home once a week to pray for the Carlsbad schools, staff members, and students. They often stepped in to help as volunteers at nearly every event and raised funds to throw Grad Night each year for graduating seniors. (Courtesy of Elaine Blackburn.)

Mark and Bonnie Packard
The Packard family is well known in Carlsbad, with so many members taking an active role in business, politics, and volunteerism. Three first-generation Packards established Packard Dental in downtown Carlsbad in 1963. Mark, a CHS grad and second-generation dentist, along with his wife, Bonnie, joined Packard Dental when Mark's uncle Ron ran for Congress. Two of Mark's sons are now a part of the family practice. Dr. Packard was honored by the Carlsbad Chamber of Commerce in 2005 with the Masters Meed Community Leadership Award for outstanding service to the community, including more than 10 years as a Boy Scouts Eagle project counselor, his ongoing involvement in Rotary Club, his church, his work in local government, and his humanitarian service. He was inducted into the CHS Hall of Fame in 2013. (Courtesy of the Packard family.)

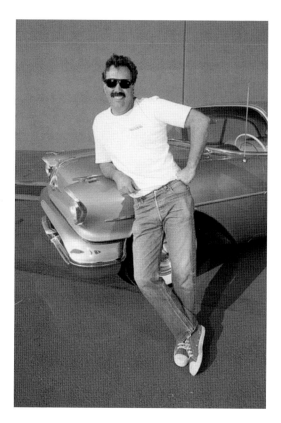

Larry Balma

Larry Balma, along with his partners Dave Dominy and Garry Dodds, combined their talents while skateboarding on the smooth new hills of La Costa in the early 1970s. Fueled by the introduction of the polyurethane skateboard wheel created by young aeronautical engineer Frank Nasworthy, the Cadillac wheel was the first major performance evolution in skateboard equipment. This inspired Larry, Dave, and Garry, who shortly thereafter formed a partnership specifically to improve skateboard equipment. Conducting design experimentation and research and development on skateboard decks, wheels, sealed ball bearings, and trucks, their company, Tracker, took off. In 1975, Tracker introduced the first modern skateboard truck, designed specifically for skateboarding by skateboarders. They incorporated high-quality performance and strength into the Tracker Truck, which was made of aircraft aluminum and steel alloy. The Tracker Fultrack truck revolutionized the skateboard, elevating it from a mere toy to a high-quality professional sporting equipment. The Tracker factory was founded in Carlsbad in 1979. By 1983, Larry and his sales manager Peggy Cozens launched *TransWorld SKATEboarding* magazine. By 1986, it jumped in popularity, ranking 71st out of 4,500 monthly magazines. This led to *TransWorld SNOWboarding*, *TransWorld Business*, *Blast*, *WARP*, *Stance*, *TransWorld Ride BMX*, *TransWorld Surf*, and *TransWorld Motocross*. TransWorld Media moved to Carlsbad in 2009 and was joined by TEN, the Enthusiast Network, with *Surfer*, *Surfing*, *Snowboarder*, *Power*, and *Bike*. The magazines, along with their digital media and online services, occupy 46,000 square feet in Palomar Airport Business Park, which includes a 5,000-square-foot skate park and event space. Recognizing the grassroots of skateboarding, the Tracker Trucks were inducted into the Skateboarding Hall of Fame in 2015, receiving the Icon Award, while *TransWorld* has become a household name among action-sports enthusiasts and artists from every corner of the globe. The rich history of Tracker is documented in a 388-page collection of photographs, stories, and reflections from the perspective of the people who worked there, as well as the professional riders and photographers who made Tracker a major icon in the skateboard world in *Tracker – Forty Years of Skateboard History*. (Courtesy of L. Balma.)

John O'Malley
Skate park developers John O'Malley and Jack Graham designed and built Carlsbad Skatepark, one of the world's first. Jack was an inventor and homespun engineer with the ability to devise fascinating creations of immediate practical application. Traveling home to Alaska after purchasing a new boat in Florida, Jack, a king crab fisherman, and his family were pirated by members of a drug cartel while refueling in Colombia. They managed to escape under the cover of darkness and limped their way into San Diego. Deciding to stay in North County, Jack sold his boat and became John O'Malley's next-door neighbor and business partner. John became the surface designer for the skate parks that he and Jack developed and owned. John lives in New York City as a graphic designer and violinist. He writes about gravity sports and still rides his skateboard to work every day. (Courtesy of J. O'Malley.)

Richard Dowdy
Richard Dowdy began taking photographs at a young age, and by high school, he started photographing surfing and sports-car races. While on summer breaks from college, Dowdy made surfboards for Hansen in Encinitas and Surfboards Hawaii in Leucadia. Upon graduation, he had multiple jobs as art director or editor of multiple well-known sports magazines. At the same time, he renewed his interest in automobile racing and was hired as a staff photographer for the Indianapolis Motor Speedway. Dowdy photographed the last 24 Indianapolis 500 events and other IndyCar races around the United States and Canada. Concurrently with auto racing, Dowdy worked for Chris Carter's *X-Files* series for several years, creating a game and other projects. He has published two nonfiction books and numerous magazine articles and as a photographer focusses on musicians, surfing, people, cars, and other interests. (Courtesy of R. Dowdy.)

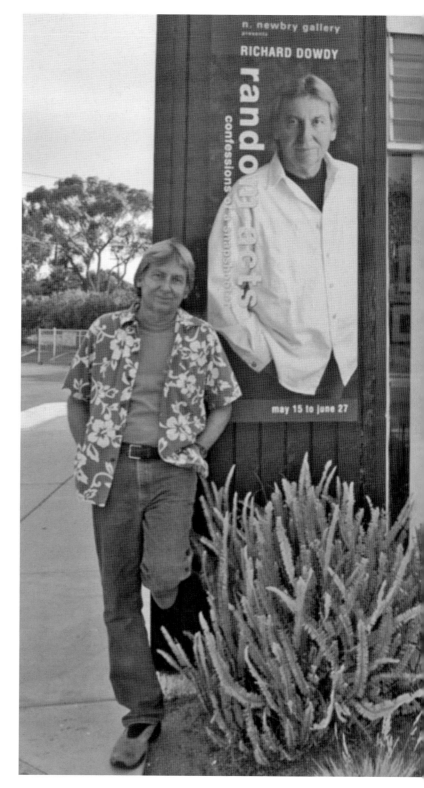

LIFE IS TOUGH.
IT'S TOUGHER IF
YOU'RE STUPID.

Rick Doty

AA Trophies is synonymous with sports is Carlsbad. First opening his shop on Friday the 13th in April 1990, Rick Doty purposely chose his grand opening date. Doty has worked with Carlsbad schools for more than 25 years and honors them on a regular basis for their continued business. When one meets the man behind the engraving machine, it is instantly recognizable that his favorite part about his business are the people. Doty states that a vital part of the business is the ability to keep secrets. He is told, sometimes weeks in advance, the honorees names of those receiving specific awards. What he does not mention is that he is known by nearly everyone in town, so that is a lot of secrets. The man behind the business is genuinely humble and very discreet; he has a huge heart and loves to make people happy.

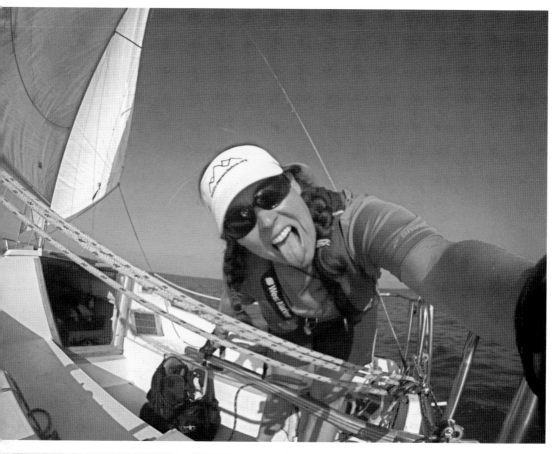

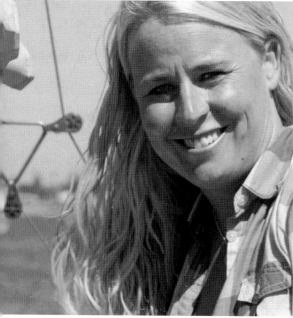

Erin Spineto

Erin Spineto was diagnosed with diabetes in 1996 as a young girl and has had easy years and hard years dealing with her disease. When she became frustrated after fighting the disease for 12 years, she turned to adventure to provide renewed motivation. She began with a 100-mile solo sail down the Florida Keys, followed up by leading the first ever all type 1 diabetic team to finish the 12.5-mile swim around Key West. She led another team stand-up paddling 100 miles up the Intracoastal Waterway in North Carolina. Erin has been featured in *Diabetes Forecast* magazine, *Insulin Nation*, *Diabetes Mine*, *A Sweet Life*, and the *Union Tribune*. Spineto wrote a book titled *Islands and Insulin: A Diabetic Sailor's Memoir* and is a true inspiration to many, particularly youth. (Both, courtesy of E. Spineto.)

Paul Vantoch and Helmut Havel
Paul Vantoch (left) and Helmut Havel (right) have met at Vinaka's coffee shop in the village three times a week for the past 10 years to play chess. They play against one another and anyone who will challenge them. They started their chess-playing coffee club with about 15 men. Profoundly interesting individually, born in Austria, Paul was 14 when World War II broke out. He relocated to the United States after the war and worked with the American government in an undisclosed position, until he retired and moved West. His good friend Helmut, born in Germany, was nine years old when the war broke out. He was forced into the Hitlerjugend (Hitler Youth), but the war ended shortly thereafter. Both men stated that when they die, "We hope that we had a glass of wine and a nice girl sitting next to us; that's how we want to go."

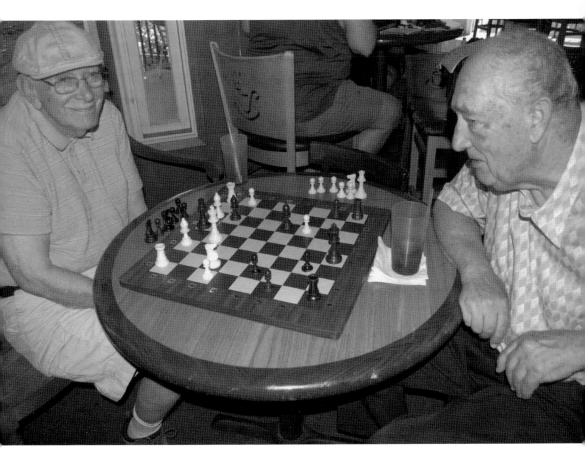

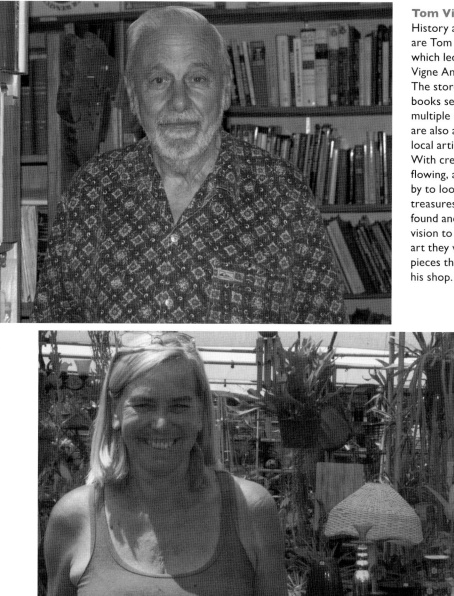

Tom Vigne
History and old books are Tom Vigne's passion, which led to opening Vigne Antiques in 1980. The store has an old books section and multiple unique finds that are also a favorite of the local artist community. With creative juices flowing, artists come by to look at the latest treasures that Vigne has found and explain their vision to him of what art they will create with pieces that are found in his shop.

Becky Parker
Growing up with parents who always maintained beautiful gardens, Becky Parker learned at an early age the value of appreciating beauty in nature. As an adult, she combined this passion with her love for treasure hunting at garage sales and Rebecca's: Becky's in the Backyard was born. Exploring Rebecca's is like walking through a magical wonderland of plants, pottery, and glassware treasures, home to beautiful butterflies and songbirds.

CHAPTER FOUR

Visionaries

Without the individuals who listened to the heart of their souls and followed uncertain paths, many would still be working at an unfulfilled day job. New organizations, clubs, businesses, and philanthropic work are born from individuals who creatively incite positive change in society. There are individuals with a true passion for Carlsbad combined with a natural inner spirit who inspire improvement. It is because of the hard work done by these selfless people that so many others benefit locally, nationally, and internationally. Carlsbad is incredibly honored to be home to a vast group of such inspirational locals.

The city of Carlsbad has multiple citizens that go to work and do their jobs, day in and day out. They are the teachers, police and fire department members, librarians, coaches, club leaders, and after-school programs. Within this diversified group of individuals are the proactive parents who saw a need for revised programs and pursued change, coaches who promote academics, and teachers who confidently speak about their faith. One can also walk around the village and find others fulfilling their destiny in a nondescript way. Stop by the local coffee house and play a pick-up game of chess with the old guys. Their stories are truly amazing. Go by the Magee House and speak with the local historian, one will be mesmerized by the untold history of the town many call home. Find solace in an organization that is specifically designed to help the families of children who are suffering from life-threatening illnesses. Create a program that promotes peace throughout the world. Head to Lola's.

This is a community of game changers. This is a town with citizens who follow their hearts, in many instances turning a negative into a positive. This is the town where one is free to embrace one's passion and feel the support from all. Carlsbad is not a town of "It can't be done." It is a town of "Why not?"

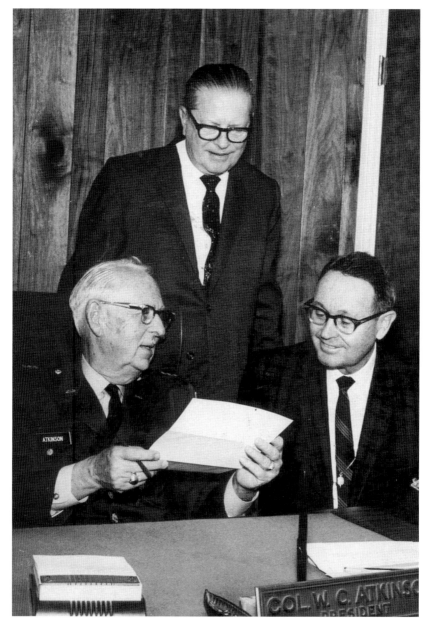

Colonel W.C. (William Currier) Atkinson
Born in 1899, Colonel Atkinson (holding paper) began working for Army and Navy Academy as vice president and commandant of cadets in 1924. Dedicated to service and character development, Atkinson then served as the school's fifth president from 1943 to 1972. During his presidency, the school's enrollment grew from 75 to 300 students, the faculty expanded from 14 to 45, and the school doubled its land ownership from 10 buildings to 26. The Atkinsons worked closely together, and his wife, Virginia Powell Atkinson, became the school's vice president and the first woman to hold a title at a military school. Virginia Atkinson passed away in 1951, and her devoted husband visited her grave daily until he died in 1983. Today, a dormitory at Army and Navy Academy is named Atkinson Hall in their honor. (Courtesy of the Carlsbad City Public Library Carlsbad History.)

Bud Lewis

Falling in love with the people and beauty of Carlsbad, Bud Lewis secured both a teaching and coaching position at Carlsbad High School. Known as "Mr. Lew," he was beloved by both students and staff. In 1970, Lewis decided to alter his course a bit and ran for a seat on the Carlsbad City Council. It was also the beginning of a legendary 40-year career as a public servant. Simultaneously, Lewis ran two businesses while a devoted councilman for 16 years and mayor for 24 years. Lewis was mayor for so many years because of his unique leadership skills. He was known by his friends as "Buddy." At the time of his death, Lewis was recognized as a devout Christian man who valued family time with his wife and children. (Courtesy of the Carlsbad City Public Library Carlsbad History.)

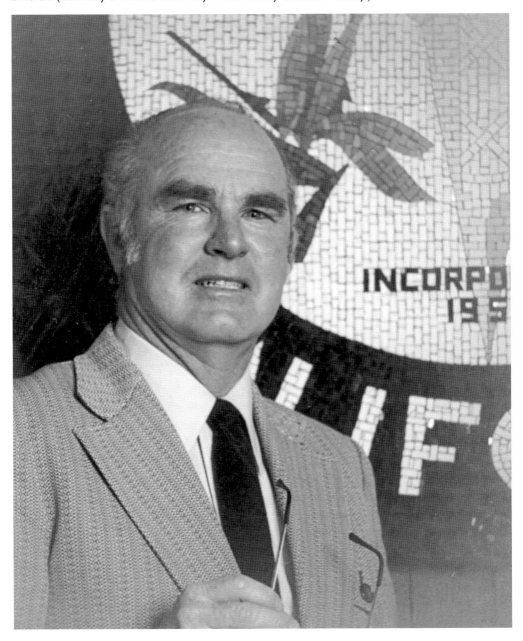

Denny Cooper

"Do not weary of doing good, for at the proper time you will reap the rewards, if you do not give up." Galatians 6:9. This is Denny Cooper's favorite Bible verse. A Carlsbad High graduate and cornerstone of the school today, Cooper is a highly respected individual by both students and staff. His entire adult life, he has asked himself what more he can do for kids. With his wife, Anna, they have 3 biological, 4 adopted, and 19 foster children. Known by the surf and skate cultures, Cooper held the first surf class in 1992 and skate class in 2006. As a result, there are now two groups of kids from CHS that used to be pushed aside who have joined the academic community and have become a part of the town's culture in a positive way. (Both, courtesy of D. Cooper.)

Brad and Beth Thorp

What causes a family to take their deepest grief and turn it into something truly inspirational? Brad and Beth Thorp created the Mitchell Thorp Foundation (MTF), which provides incredible blessings for families whose children suffer from life-threatening illnesses, diseases, and disorders. The MTF provides financial and emotional support to each desperate situation. Beth and Brad, longtime Carlsbad residents, have taken the strength demonstrated by their son Mitchell during his five-year battle with an undiagnosed illness to form a foundation that honors him. The couple feels fortunate to keep his memory and spirit alive through the foundation and the children and families MTF has helped. (Courtesy of the Mitchell Thorp Foundation.)

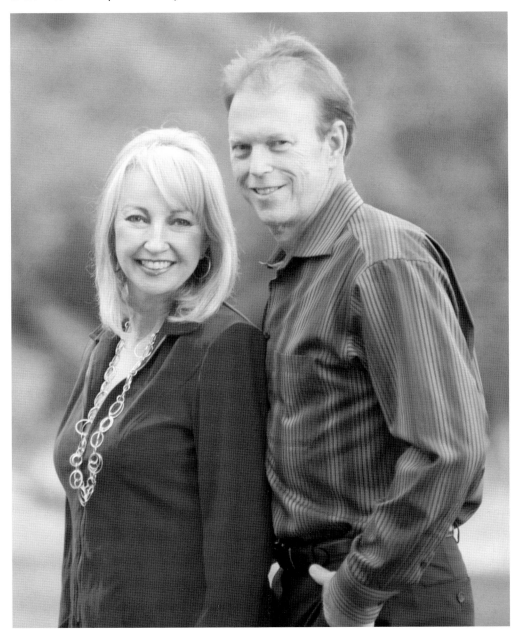

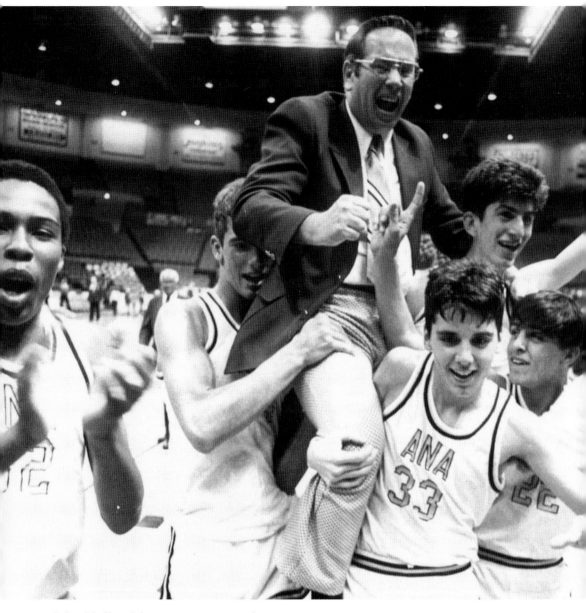

John Maffucci (ABOVE AND OPPOSITE PAGE)
Ever since Army and Navy Academy planted its roots in Carlsbad, one of the school's primary tenets has been athletics. Throughout the academy's impressive history, there have been many outstanding coaches who have carried the Warriors on to numerous victories. But there has been no greater coach than John Maffucci. In 1956, Maffucci arrived on the campus as a new physical-education teacher and athletic coach, along with his family, including sons Bill ('74) and Chris ('85). He was quickly named athletic director just over one year later. During his 59 years of service to the school's athletic program, Coach Maffucci had a remarkable career and record. To honor Coach Maffucci's tenure and 59 years of dedicated service, the academy officially retired the number 59 on an honorary basketball jersey in 2015. It will hang in the hall of fame to remind future generations of Warrior athletes of Coach Maffucci's dedicated service. (All, courtesy of J. Maffucci and the Army and Navy Academy.)

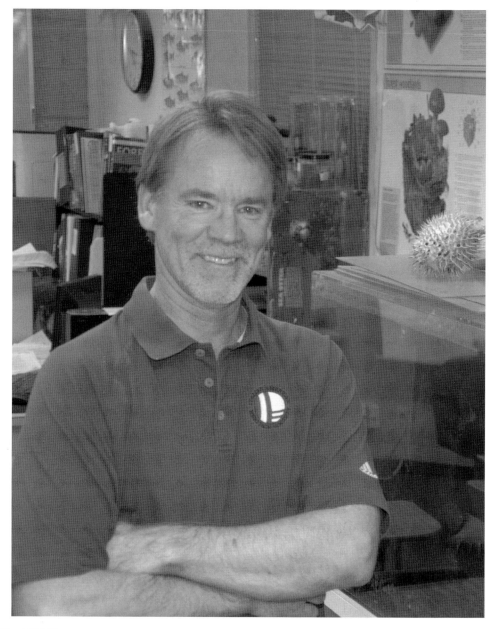

Karl Walker
A National Board–certified teacher and adjunct professor, Karl Walker's Advanced Placement biology class has earned legendary status. One student who survived framed his experience by stating, "Let us call him the Gunslinger. With the reputation of emptying his freshmen classes of potential students as fast as a cowboy with a revolver disposed of bad guys in a saloon, the Gunslinger shows no mercy." Walker also teaches general science and raises steelhead trout in his classroom, releasing them on an annual fieldtrip to the Sweetwater River in the Cuyamaca Mountains. He had the unique opportunity through a grant that he received from the America's Cup "Young America" team to make replica racing boats in his oceanography classes. The science department chair for 20-plus years, Walker races sailboats, is an avid skier, loves model railroading, and is commodore of the Oceanside Yacht Club.

Linda Ledesma

A native of Carlsbad, Linda Ledesma was raised in the historic barrio area and graduated from Carlsbad High School in 1965. Growing up in Barrio, Carlsbad has always been a source of great pride for Ledesma. As a bilingual and bicultural Latina, she is blessed with a deeper sense of cultural sensitivity and emotional empathy. These traits have been vital in her focus on the critical issues facing youth and their families, with emphasis on outreach to the Hispanic community. Ledesma has served as a community counselor for various agencies in the North County for nearly 30 years, most notably as coordinator of the Carlsbad Police Department's juvenile justice program since April 1989. Ledesma received the Enrique "KiKi" Camarena Law Enforcement Award in 2013 and hopes to be remembered as a person of faith who cared deeply for Carlsbad and all of its residents. (Courtesy of L. Ledesma.)

Susan Gutierrez

With academic training and a passion for archival work, Susan Gutierrez became a member of the Carlsbad Historical Society in 1993. Simultaneously, she also began working for Carlsbad Public Library in the circulation department, which eventually evolved into organizing and growing the Carlsbad History Room collection. With a true connection to all things historical, Gutierrez enjoys creating interpretive displays for the Carlsbad Historical Society Museum because she thinks it is important to preserve the past for children to learn and appreciate everything and everyone that have gone before them to create this place that they call home. Ultimately, it is about the sense of place and understanding of how people lived, worked, and traveled. (Courtesy of S. Gutierrez.)

Jay Klopfenstein

With a passion for all things green, Jay Klopfenstein is cochair of the Carlsbad Chamber of Commerce's green taskforce–sustainability committee. His annual Chamber Green Business Expo and EcoTour, along with monthly meetings in which sustainability experts share best green practices with businesses and schools, have become a vitally important facet to not only the community but also the overall health of the planet. Additionally, Jay is president of the Carlsbad Community Gardens Collaborative and an educational advisor for the Buena Vista Lagoon Foundation/Carlsbad Watershed network, both vitally important projects. Having a passion for sustainability, Jay creates opportunities for schools and business communities to instill best practices for the local environment. (Courtesy of J. Klopfenstein.)

Leo and Dianna Pacheco

The Pacheco family arrived in Carlsbad in 1947. Quickly settling in the barrio, their first home had an outhouse and no running water. Leo's parents worked in agriculture, but by 1955, transitioned into being owners of their own restaurant, Pacheco's Place, and his mom used to feed fresh tortilla and bean burritos to the migrant workers and hobos that passed through town on the railcars. Leo felt fortunate to grow up in a family-oriented and supportive neighborhood. During the 1960s, Leo became a political activist during the "Great Boycott" and met Cesar Chavez during his famed fast. As an adult, Leo served on many committees and was the regional coordinator for Marriage Encounter. Leo learned to surf in 1956 and asserts that the surf culture "is to die for." He and his wife, Dianna, are proud to say that their five children are first-generation college graduates. (Courtesy of the Pacheco family.)

Consuelo Trejo and Ofelia Escobedo

Originally owned and run by Reyes and Dolores "Lola" Jauregui, 7-Up Market and Deli remains an icon in the barrio but is now known as Lola's Mexican Market and Deli. Serving the Hispanic community since 1943, Lola's remains in the family today. Consuelo "Connie" Trejo (left) and Ofelia "Ofie" Escobedo (right) grew up in their parents' 7-Up Market alongside their youngest sister, Frances. Continuing the family tradition started by their parents, their own children and grandchildren work with them today. Connie's nephew Henry, a primary figure in Lola's, calls his aunt the lynchpin of the community. She is a two-time cancer survivor and political activist who single-handedly challenged the city to clean up and take pride in the neighborhood in which she grew up. The entire community of Carlsbad has since risen in banding together to take responsibility for the beautification and preservation of the barrio. Connie is the sister who initially took over the deli from her parents and has worked there from a young age. She said that she is the quiet one. Her name, Consuelo, means to council and show support for others, and Connie feels that this is the way she strives to live her life. Connie works hard to make sure those who come to her market are well cared for, no matter their circumstances. Ofie has lovingly nicknamed Connie "Mother Theresa 2." Connie and Ofie are truly a complementary team. It is clear that they work very well together, each personality complementing the other. The sisters are barrio historians and amazing storytellers; they have a wonderful sense of humor. What is most enjoyable as an outsider to witness is how they constantly laugh at, and with, each other. There is an enjoyment when they are in each other's presence that is apparent. Together they live their lives with a common theme: step up to responsibility, respect each family member, have integrity, work hard, believe in God, and give back to the community. In 2000, the sisters created scholarships for Carlsbad Village Academy for the Hispanic youth in the community. The sisters have a passion for slowing the dropout rates of students from the neighborhood. Well loved and respected by multiple generations, Lola's was voted by Carlsbad High School students in 2015 as their favorite place to eat. Connie and Ofie are pictured here with a painting of their parents.

Mark Dankberg

Mark Dankberg has become one of the foremost entrepreneurs in the satellite sector since cofounding ViaSat in 1986. He has held the position of chairman of the board and chief executive officer since the inception of the company and is recognized as an industry expert in aerospace, defense, and satellite communications. He has coauthored several military standards on satellite networking and holds a number of patents in communications and satellite-networking technologies. One of the things that makes ViaSat unique to its employees is its corporate-outreach program, Vpartners. ViaSat allows employees to choose the causes they would like to support, provides matching funds, and holds events to help employees raise money and awareness for their chosen charities. It is not uncommon to see ViaSat as a sponsor at many Carlsbad fundraising events. (Courtesy of ViaSat.)

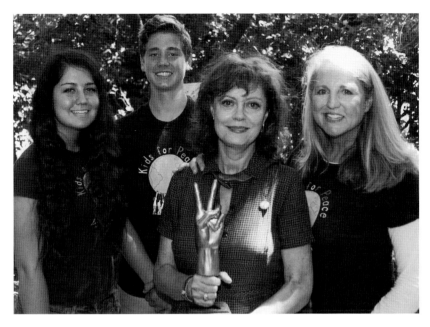

Jill McManigal

Jill McManigal started Kids for Peace with Danielle Gram, a global 501(c)3 nonprofit that creates peace through youth leadership, community service, global friendships, and thoughtful acts of kindness. Kids for Peace has launched over 350 interconnected chapters around the world, in Iraq, Pakistan, Kenya, Liberia, Rwanda, Palestine, Bolivia, and many more. The Great Kindness Challenge was piloted with three Carlsbad schools and is now in all 50 states and 47 countries, impacting over two million students in 2015. Through Kids for Peace projects and programs, youth from all socioeconomic backgrounds are empowered to become part of positive solutions leading to a healthy and harmonious planet. The Peace Pledge, pictured here behind a group of students in Pakistan, was presented at the United Nations and on the House Floor of Congress. McMagnigal is pictured above with her children Hana and Bodhi and actress Susan Sarandon. (Both, courtesy of J. McManigal.)

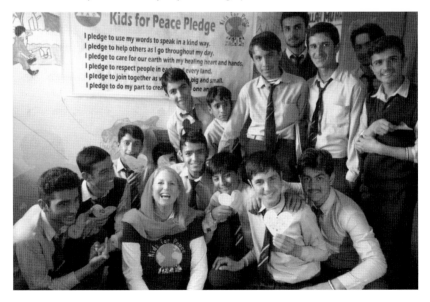

Mike Frazee

Mike Frazee is known by the community as a deacon who goes to the next level for God, family, and friends. In 1996, Mike was ordained as a deacon in the Catholic Church. After a five-year course of study in which his wife, Chris, also participated, Mike is the only confirmed deacon at St. Patrick's Church. It is a volunteer position that it is a true calling. As a young man, Mike felt the call to become a priest. But once he started high school, he said that his focus temporarily shifted as a result of his female classmates. His marriage in 1971 and four children never took away Mike's commitment to the church. If the Catholic Church made the decision to allow priests to be married, he would answer that calling with his wife's full support. (Courtesy of the Frazee family.)

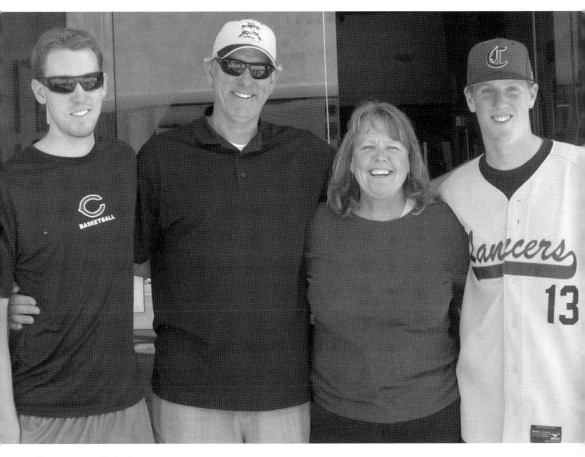

Rosemary Eshelman
A self-professed youth advocate who is also a networking queen, Rosemary Eshelman has a heart for youth development and the Carlsbad Unified School District. In 2006, Eshelman took a position on the board of YES, a Youth Enrichment Services program. The goal of the YES collaborative has been to enhance local efforts to identify issues and improve communication among all service providers who currently work with youth. Happily married to David and the mother of two sons, Sam (left), who teaches at Army and Navy Academy, and Thomas (right), who just signed with the Houston Astros baseball club, Rosemary has a passion to connect youth to the community so that they feel a part of where they live and grow and become contributing members of society. (Courtesy of the Eshelman family.)

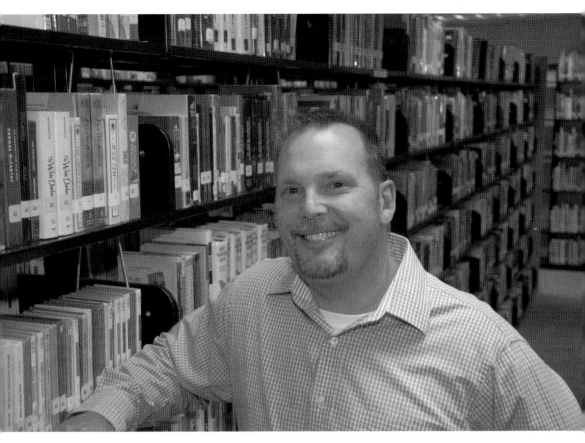

Jeff Spanier
Winner of the Chargers Champions Award for outstanding teaching and also selected as Carlsbad District Teacher of the Year, Jeff Spanier is a great example of perpetuating the family tradition of attending Carlsbad High School, marrying one's high school sweetheart, and then moving back to make a mark on the school and the community. For the last few years, Spanier has been the voice of the Lancers, announcing home football and basketball games. But his true passion revolves around student success. Working with AVID, a college-readiness program, Spanier has helped hundreds of students prepare for and enter college as the first generation of higher educated in their families. If one cannot find Spanier at school, he is walking on the beach, riding his mountain bike, or grading papers at a coffee place in the village.

Jeff Riccitelli

"The most fulfilling part about being a coach is the relationships that you build with your players and students." A 1987 CHS grad, Jeff Riccitelli returned to his alumni school to teach Spanish and coach. "Ric" coached volleyball his first five years but has always been the men's varsity soccer coach. The 2014 season was Coach Ric's most memorable in over 20 years. The varsity team won CIF and played in the state finals. His son Collin played on the team, and his dad, Ron, was one of the assistant coaches, truly rounding out the exceptional experience. Carlsbad High School Teacher of the Year in 2007 and North County Coach of the Year in 2013, Ric married his high school sweetheart Carey more than 20 years ago, and they also have a daughter, Camryn.

Doug Green

A visionary educator who loves teaching middle school English, Doug Green was asked to help open a new school site in 1999 and develop a new high-interest broadcast-journalism elective. Embracing the challenge, a new and rigorous program was developed that taught students to manage deadlines, deal with technical challenges, and learn to become critical viewers. It was hands-on academia. Today, many of Doug's former students are now working in the professional world as a result of his programs. They have become news anchors, reporters, filmmakers, and graphic and animation artists, and one recently won an Oscar. After more than a decade of committed work, the broadcast-journalism programs are now recognized with their own 501(c)3, an active booster club, and a board of directors. Green has received recognition as teacher of the year and for excellence in broadcast journalism. (Courtesy of D. Green.)

Tony Hawk

When Tony Hawk's brother handed him a blue fiberglass skateboard at the age of nine, Tony had no idea he would become the most famous skateboarder of all time. At age 14 he turned pro, and by 16 he was widely considered the best skateboarder in the world. By the time Tony was 25, he had entered an estimated 103 professional contests, winning 73 and placing second in 19—by far the best record in skateboarding history. He was the world champion for 12 years in a row. But what makes Tony truly unique today is his philanthropy. Known as a game changer for his philanthropic work, the Tony Hawk Foundation has given away over $4 million for development of more than 500 skate park projects throughout the United States. (Courtesy of Dale May.)

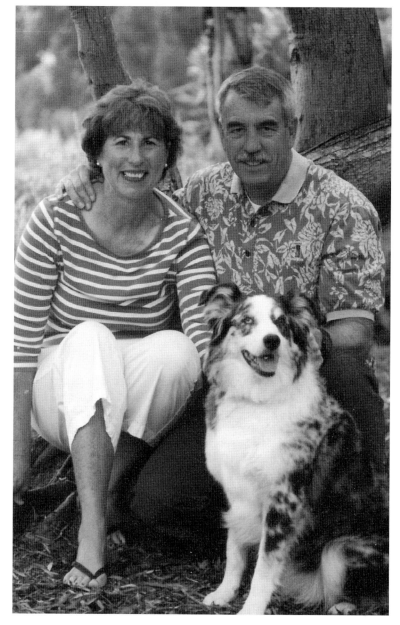

Bob and Elaine Blackburn
As parents of a son who loved surfing more than academics, the Blackburns became involved in the development of pioneering a surfing physical-education class for Carlsbad High School. Having to create the notion that this would be the connection that would keep kids in school, the Blackburns, along with other parents, banded together in solidarity searching for recognition and sponsorship from the school for their kids' sport—surfing. The moms felt that if their children could start the day in the water, and then go to school, they would be more inclined to focus on academics for the remainder of the day. Unfortunately, it was not until some of the dads got involved that the superintendent and school board gave the program support. The class was instituted in 1982 and has been growing in popularity ever since. (Courtesy of the Blackburn family.)

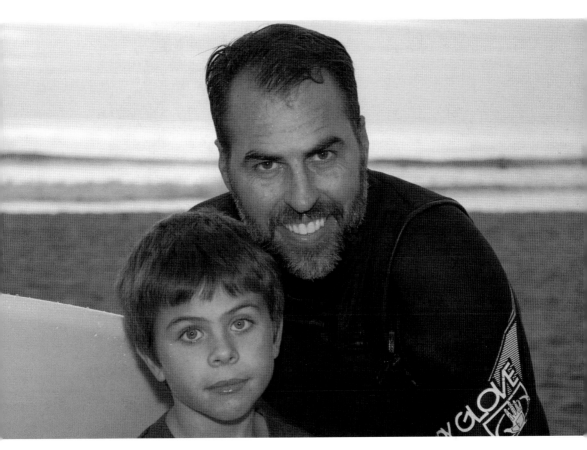

Jake Blackburn

Growing up in a surf town with a high school that saw the need to provide an outlet for the surf culture was instrumental in Jake Blackburn's success (pictured here with son Quinn). Ultimately, it inspired him to return to Carlsbad High School in 2005 after college as a high school counselor and a surf-team coach. As head surf coach, Blackburn has teams of both boys and girls on longboards, short boards, and body boards. He states that the team's longevity has to do with the commitment on the part of the coaches and the way they impact their students' lives on a daily basis. Blackburn's commitment and philosophy to give back some of which he received has strengthened the surf program from 20 kids to over 65 active members today.

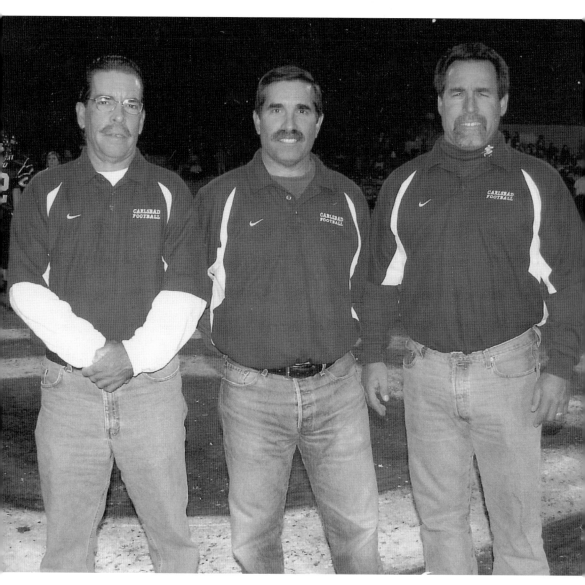

Chain Gang

Take three brothers and one good friend who love football, and put them together, and the result is Carlsbad High School's famed "Chain Gang." The legacy began in 1981 when the Frazee boys, along with Scott Koopsen, took on the challenge of running the chains at the home football games. The Chain Gang from Carlsbad High School is famously known throughout California. They were lauded as the best chain gang in the country and received an invitation to attend the year-end referees' dinner, a tremendous compliment and rare event for chain crews. One cannot go to a home football game without appreciating the dedication of this group of guys. Pictured here from left to right are Pat, Mike, and Tim Frazee. (Courtesy of Mike Frazee.)

CHAPTER FIVE

Livin' the Dream

Sketching doodles on a notepad, daydreaming in class when one would rather be playing guitar, carrying a football everywhere imagining a contract with the NFL, riding a skateboard from class to class, dreaming of moving to America—everyone has imagined what life would be like, if only. At some point, each individual has had a dream about what or who they would want to be when they grow up. Some begin to live their dream at a young age, guided by the encouragement of their parents. Others had the dream for years, only capable of achieving it once they were established professionals. Then there are some who are fortunate enough to fall into the fine graces of the perfect niche, not really recognizing that they have achieved their dream until someone points it out to them.

Carlsbad seems to attract a unique set of highly motivated overachievers. There are so many success stories that they cannot fit within the pages of one little chapter. Locally grown athletes have brought home Olympic medals, many of them gold. CHS alumni have received Oscars, and others have been fortunate enough to wear championship rings. Today the daydreamers are the locals. The locals are the contributors, and Carlsbad reaps the benefits. There is beautiful street art throughout the village that inspires the imagination; try going on a Carlsbad crawl to look for new pieces one day. Music is a large part of the village, and one can walk a short two-block radius on the weekend and find a variety of genres to listen to. Authors are inspired, sometimes from afar, but always happy to return home to write.

There are also the multigenerational families of success. Stories of riding a horse to the lagoon or a skateboard down a large hill breaking the record at 70 miles per hour. The up-and-coming local surfer who just happened to be a very young recording artist with a philanthropic heart, the athletes that fought hard from struggling families to achieve greatness both professionally and now as coaches, the boys who unknowingly broke a school record—these are the people who achieved their dream, still live their dream, and share their dream with everyone around them. They bring greatness to Carlsbad.

M.G. Crisci

M.G. Crisci is a critically acclaimed author and outspoken cultural activist who has written eight books based on true stories and life experiences. He collaborated with award-winning Russian producer-director Vladimir Alenikov to coauthor a screenplay, *The White Lily*, inspired by his bestselling book. Crisci has spoken worldwide about the use of cross-cultural initiatives to improve Russian-American understanding at the United Nations, the Russian Cultural Centre, the Ukrainian embassy in Washington, DC, the American embassy, and the American Center for Democracy in Moscow. He is the recipient of an international award for editorial excellence by *Rossiyskaya Gazeta* for his books, editorials, and blogs about everyday Russian life, its heroes, and its culture. He was also the first American author to be awarded a certificate of achievement by the Federation of Russia for enhancing nonpolitical communications between the two nations. (Courtesy of the Crisci family.)

Paul Henry

A New England transplant, Paul Henry opened his first shop in Carlsbad Village behind an antiques store in 1978 and then moved to his present location in 1981. Henry serves multiple antique dealers working in restoration and repair. This led to his own creation of functional art through beautifully crafted pieces of furniture. He was subsequently invited to teach his craft at Palomar College, where he continues to instruct to this day. Henry is fascinated by the stories that furniture can tell. The record of use and abuse and the evidence of repair and alterations all are there for him to see. As a furniture maker, he knows that some of the story begins with himself, so he attempts to honor that privilege by using antique salvage and found objects to build in the history of his personal pieces to manufacture a memory.

Glenn Malone

Born in Liverpool England, Glenn Malone has had a passion for soccer since childhood. He was privileged to play two years for Wigan Athletic as an apprentice professional and three years as a semiprofessional at Skelmersdale before deciding to leave England and move to San Diego to coach. Malone found his way, along with his good friend Carl Higham, to Carlsbad in the early 1990s by way of Ashton-In-Makerfield, England, and began coaching for Leucadia Lightning. Working his way through the organization, Malone helped the club to make a valuable transition in becoming Carlsbad Lightning in the early 2000s. Today, Malone is the boys' director and Higham directs the girls. Malone was also the frosh and junior varsity soccer coach and supported varsity soccer at Carlsbad High School for 16 years. His character is demonstrated through his volunteerism at the local elementary sports programs.

Matt and Tim Clinton

A feat yet to be beat, two brothers who grew up playing baseball and soccer suddenly switched to tennis and left their mark on the record books at Carlsbad High. Matt Clinton ('99, right), who walked onto the tennis courts as a freshman with a borrowed racket, asked the coach if he could give it a try. Younger brother Tim ('03, left), forever competitive with his brother, followed Matt's lead and made the same choice four years later. Graduating four-year lettered varsity tennis scholar athletes and captains (Tim lettered varsity soccer as well), the culminating event was when each received the Chuck Gibson Perpetual Trophy for representing the ideals set forth by the coaches demonstrating leadership on and off the courts. The Clinton boys are the only brothers to have achieved this legendary award at CHS. (Both, courtesy of the Clinton family.)

Susanna Kurner

Susanna Kurner grew up with the memory of her grandmother's house in the village and music always in her parents' home. Her mother played guitar and flute and sang. Her father played piano and banjo. Susanna began in musical theater and a cappella groups while in school. She then moved on to study classical vocal performance at Manhattan School of Music in New York City, which culminated in a bachelor of music degree. Susanna eventually ended up back in Carlsbad and worked as a teacher and store clerk at Giacoletti Music. It is there that she discovered her love for the ukulele and began to incorporate that into her performances. She currently teaches singing and ukulele and often has her students sit in on her performance for the Friday Night Live series put on by the Carlsbad Village Business Association. "I love giving my students the opportunity to perform in a casual, low stress environment. It helps them build confidence and their parents love it!" She has performed for many city functions and was even a representative in an operatic vocal competition put on by the sister city of Karlovy-vary in the Czech Republic. Susanna was honored to have been able to represent Carlsbad in that beautiful town. She can often be seen performing with her music partner, former professional skateboarder Adrian Demain. They play vintage country music (Susanna and the Troublemakers), as a Hawaiian duo (Tiki Two), and as a jazz duo. They often perform at Coyote Bar and Grill and have also been a part of the Carlsbad Music Festival. She currently lives in Carlsbad with her husband, artist Bryan Snyder, son Henry, new baby girl Stella Louise, and their cat Trixie. Susanna loves to play and sing to her children and hopes the tradition of music is passed down to her children as well. Her family remains a big part of her life, and she feels very lucky to have her parents and sister living within a one-mile radius. (Courtesy of S. Kurner.)

Bryan Snyder

Walking through Carlsbad Village can be an artistic adventure if one wanders freely. Encouraging this type of visual exploration has been Snyder's goal since he graduated from college in 2006 and returned to his hometown. In 2007, he opened Snyder Art and Design on State Street with the idea of an open-door-policy art studio allowing visitors to experience the creative process of a professional artist at any time. In addition to his studio, he established carlsbadcrawl.com, a blog dedicated to encouraging a more artistic culture in Carlsbad. He has also hosted many art shows, community gatherings, art scavenger hunts, and street-art installations. Snyder continues to create art in Carlsbad, and many of his early randomly placed, seemingly spontaneous, art that shows up can still be found today. Snyder has doodled his entire life and spent years traveling throughout the United States and the world, including Australia, China, Central America, and Europe, leaving his artistic mark for others to admire. A third-generation Carlsbad resident, never wanting to leave but desiring to be amongst fellow street artists, Snyder drove four to five days a week to Los Angeles's colorful walls of Melrose Avenue in West Hollywood for five years to paint alongside some of the best. After countless street installations, gallery shows, and collaborations with some of LA's top street artists, Snyder was honored with the Los Angeles Street Artist of the Year award in 2012. Shortly thereafter, Snyder refocused back on his hometown, where Carlsbad Village again became his canvas of choice. His newest project, titled *The Carlsbad Art Wall*, invites LA street artists to introduce their art to Carlsbad on a rotating art wall. This is when Justin Jachura from Senor Grubby's donated his outside restaurant wall and monthly stipend to have a new wall of art created about every four to six weeks. Snyder is in charge of curation, public relations, and management. The city benefits and is forever curious as to what the next piece of art that will be commissioned. But back to those pieces of art that just show up around town. Be sure to look carefully at doorways, cinder blocks, corners in parking lots, and elsewhere; one never knows what Bryan Snyder might doodle next.

Sean Dominguez

A third-generation Carlsbad resident with a fourth generation on the way, Sean Dominguez came from a family of gifted artists. He has been drawing and painting since he can remember. In the late 1980s, friends and family started to commission small works from him, but his first real gig was with the Rusty clothing line. Locally, Dominguez's murals can be seen at Pizza Ports, Z Market, PCH Bar and Grill, Surfside Tap Room in Oceanside, Mother Earth in Vista, and people's homes. In Old Town, he has murals at Café Coyote, and while traveling to Bali, Indonesia, to surf, he painted there. Dominguez is best known as the artist for the North County Beer label, Lost Abbey Labels, and 90 percent of Pizza Port's marketing. Always allowing for growth and the evolution of his talents, he remains inspired by others' techniques in the art community. (Courtesy of S. Dominguez.)

Martín Barba

Proudly raised in the barrio by a loving single mom, Martín Barba was handed a tennis racket as a young child and instantly fell in love with the sport. Barba made it to the professional circuit from 1985 to 1994 and played against tennis greats like Jimmy Connors, John McEnroe, and Andre Agassi, all of whom became great friends. He is the only player who achieved winning all three national titles, referred to as "gold balls," which included champion of the Men's Open, Men's 25s, 30s, 35, and 40s. He played on six international teams as either No. 1 or No. 2 against 31 other countries, and when he retired he became Martina Navratilova's hitting partner for three years and John McEnroe's for two years. He then worked 15 years with Pancho Segura, a father figure to Barba since he turned 18. Today, Barba is a private tennis coach.

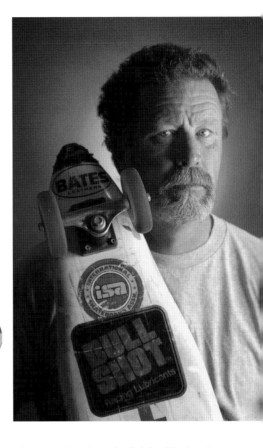

John Hughes

"Once a skateboarder, always a skateboarder." John Hughes is a risk taker, on and off his skateboard. The need for speed drove him for going downhill, as fast as he could, while either on his knees or flat on his back—feet first—with a bedroom pillow under his head. Using his shoe as a brake led to donations by Vans Shoe Company when designing their first skate shoe prototype. His risky behavior paid off on Signal Hill in 1976 when he was clocked knee boarding at 54 miles per hour. The next week he went over 70 miles per hour on a hill in La Costa, luge style. This motivated Hughes to make a better skateboard wheel, and his company was born. Today, the company has two entities, Unlimited Freighting Objects and WHAT. (Both, courtesy of Lance Smith.)

Marshall Lubin
A worldwide traveler and adventurer who circumnavigated the planet before he was 20 years old, Marshall Lubin eventually became an author. In his 20s, he toured South America, including the Amazon rainforest, and Mexico. At the age of 30, he joined the Navy and volunteered to join the Navy's special warfare program, which led to a stint at Seal Team One. Becoming a chiropractor upon leaving the Navy, Lubin owned his practice for 14 years while serving on several foundations and boards in the community. He currently volunteers his time with Challenged America, a nonprofit that provides therapeutic services for the handicapped through sailing on San Diego Bay. Lubin is also the author of *From Boys 2 Men*, *An Adventure in Paradise*, and *Night Moves*. Both are loosely based on his life experiences. (Courtesy of M. Lubin.)

Lance Smith
Renowned as one of the foremost skate and surf photographers, Lance Smith is revered as one who is incredibly versatile and known as an innovator in his style and use of equipment. For over 40 years, Smith has pinpointed the California lifestyle like few others. Documenting the evolution of surf and skate, Smith has archives filled with history from young performers like musical giants Crosby and Nash live on stage in Santa Barbara to Phil Mickelson golfing in a tournament at Torrey Pines. His latest project is working alongside Larry and Louise Balma, of Transworld Publishing, on a book written of the skateboard world from the 1970s and 1980s while still shooting his famed coastal photograph sessions. (Courtesy of L. Smith.)

Thomas Eshelman

Carlsbad native and a graduate of Carlsbad schools, Eshelman was a three-sport athlete participating in soccer, basketball, and baseball while growing up. Having a true love for baseball, Eshelman was a pitcher and a catcher, but eventually he shifted his focus to pitching. This led to the starting pitcher position his freshman year at California State University of Fullerton. During his junior year, and after breaking multiple school records, Eshelman pitched to lead his team to the college world series in Omaha, Nebraska. As closer against Louisville, Eshelman was simultaneously drafted by the Houston Astros in the second round. Eshelman has volunteered for the Carlsbad Library summer reading program, helped younger ball players through Carlsbad youth baseball, volunteered for Kids Are Worth a Million, and helped at Brother Bennos. Pictured here are, from left to right Sam, Rosemary, Thomas, and David Eshelman. (Both, courtesy of the Eshelman family.)

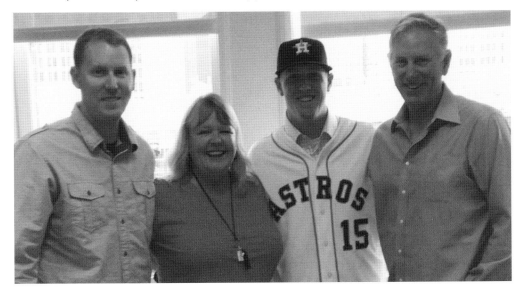

Kristianne Kurner

Kristianne Kurner is the cofounder, president and executive artistic director of New Village Arts, Carlsbad's award-winning professional theatre and arts company. First opening in 2000, Kristianne has produced, directed, acted in, and designed a portion of every production over the past 15 years. She has grown the company from a budget of $1,500 working out of a converted chicken coop in Magee Park to a budget of over $500,000 in its beautiful location in the heart of Carlsbad Village. Her work has received numerous awards, including San Diego Theatre Critics Circle and KPBS awards for theatrical excellence. Kristianne received her bachelor's degree in theater from the College of William & Mary in Virginia and master's from the Actors Studio Drama School in New York. She is proud that her children are her family's fourth generation in Carlsbad. (Courtesy of K. Kurner.)

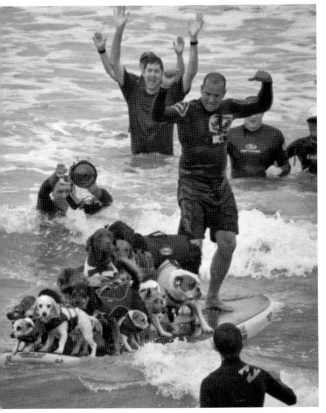

Scott Chandler

A third-generation Carlsbad resident whose father used to ride his horse to the lagoon, Scott, known as Cranny, grew up on his surfboard. Today, his favorite pastime is stand-up paddleboarding and hydrofoiling, but when he was in high school he had the unique opportunity to try out prototypes of Tom Morey's bodyboards at the ground level. This led to the pro circuit, where he used to train and travel with pipeline master and neighbor Joey Buran. Scott was a big-wave pro, conquering a 63-foot wave, and he presently holds the world record for the most dogs—17 to be exact—on his surfboard while riding a wave. Scott started his own surf company in 1986 shaping boards, popularly used by many NFL players and individuals in the entertainment industry, and has had the privilege of working on many movie sets as an advisor for water safety. (Both, courtesy of Killerimage Photography.)

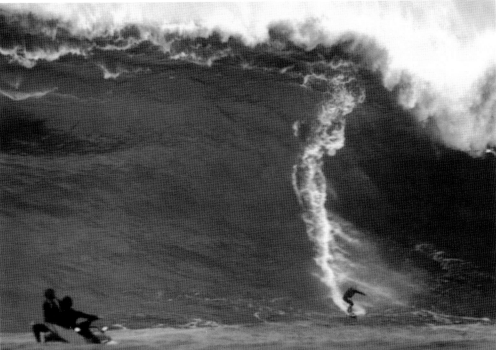

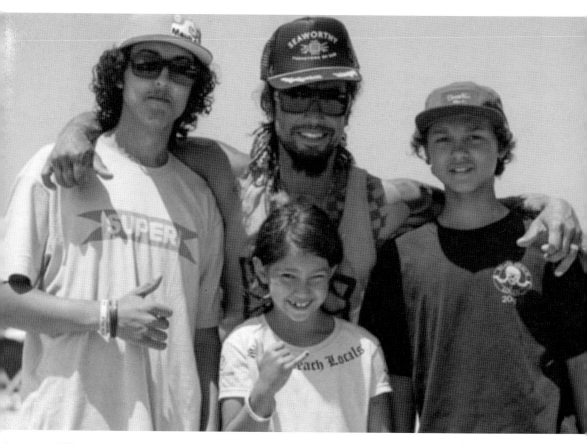

Ulises Thomas

A former professional surfer turned competitive paddleboarder, Ulises Thomas, known as Uly in the community, can be seen most days surfing at Warm Waters in a neon yellow-green wetsuit. It makes him easy to spot if one does not recognize his style on the water. Uly is a third-generation Carlsbad resident and believes that the surf community is unique. To quote an excellent Uly metaphor, "We are a good mixture of spices." Uly loves to give back and is a part of multiple local events that he has promoted, developed, or supported through the years, including the State Beach Classic held annually at Tamarack State Beach. Proud to raise his children, Presley, Slater, and McKinsey, in Carlsbad, Uly states that the unique people that live here are like the roots of a tree, their ancestors were here first and the tree continues to grow. (Courtesy of Thomas family.)

Cody Lovaas

Recipient of the 2014 San Diego Music Awards Best New Artist at the age of 16, Cody Lovaas is the youngest person to have ever received this prestigious award. Lovaas has extraordinary musical ability as a singer, songwriter, and musician. His great talent was recognized by singer-songwriter Jason Mraz at a chance show at the Hill Street Café, and he has since made Lovaas his protégé. He is often inspired musically while surfing—though he loves all board sports. What is unique about this teenager is his sense of humility and gratitude. Giving back to the community, Lovaas has been involved with Rady Children's Hospital, Surfing with the Blind, and the Mitchell Thorp Foundation, among others, and is the youngest ambassador of philanthropic foundations such as SurfAid, Natural High, and Guitars in the Classroom. (Courtesy of Nikelle Schlachter.)

Andy Tomkinson

All-American water polo champion Andy Tomkinson is a second-generation Carlsbad High School graduate. He then transitioned to UCSB to play volleyball and holds the record for the most blocks in a season. From there, Tomkinson transitioned into professional volleyball, playing for a team in Innsbruck, Austria, before returning to Southern California to become a physical-education teacher and volleyball coach at CHS. Having lived in Carlsbad for 35 years with a wife who also coaches and teaches math at CHS, Andy brings back to the community and the athletes a unique perspective and experiential background that has benefited the school. One can often hear him saying his favorite quote: "What were they thinking?"

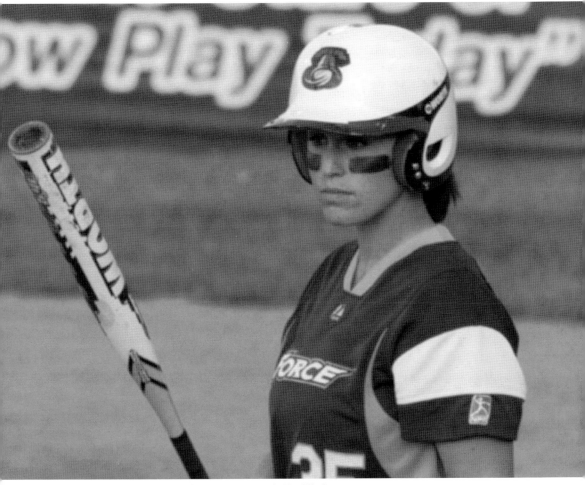

Danielle Kinley

Locally grown professional softball player Danielle Kinley left her career specifically to return to her alma mater as varsity softball coach to the next generation. Kinley has played softball since she was eight years old and was a four-year varsity player at CHS. Kinley received a softball scholarship at Penn State and after graduation was drafted in 2009 by the Philadelphia Force, which gave her an opportunity to play with some of the best in the world. She had coaching opportunities and a session to play ball in the off-season in Germany for a summer but returned to Carlsbad to become a teacher and coach. Hired by CHS in 2013, Kinley led her team to the first-ever open division CIF title in 2014. Simultaneously, the same year, Kinley was honored with the hanging of her jersey on the Carlsbad Wall of Fame. (Courtesy of D. Kinley.)

Ron Juncal (ABOVE AND OPPOSITE PAGE)
Studio 2 evolved from a friendship between two old friends who wanted to find a way to do art for a living. Ron Juncal was half of the original partnership. After one year, their first employee, Phyllis Swanson, was hired. Although Ron's original partnership went their separate ways, he continues to work with Phyllis to this day, creating art and offering a place for artists to be employed in the creation of art. Creating works of art for both public and private spaces, ranging from murals and artistic embellishments in private residences to art in places such as Rady Children's Hospital and Sea World, the Studio 2 team has also volunteered hundreds of hours bringing art to the community through the creation of art festivals and arts education in the schools and community programs. (Courtesy of R. Juncal.)

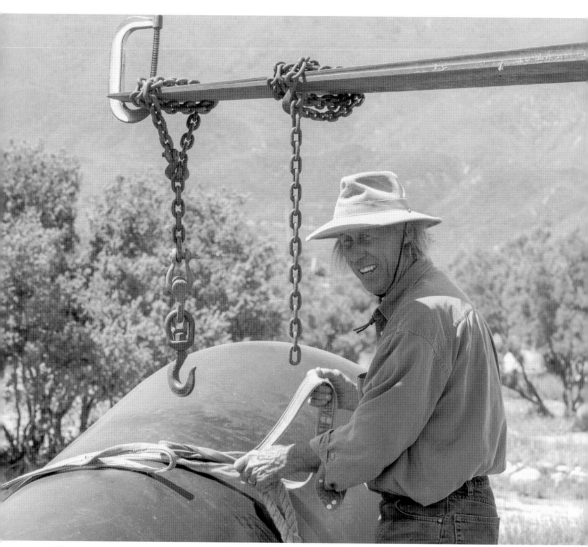

Kenneth Capps

For more than 40 years, Kenneth Capps has created a significant body of work that has gained national recognition. As an artist and sculptor, Kenneth's work can be found in several exhibitions through the United States. Honored with multiple grants and awards, Kenneth has participated in nearly 60 group and over 20 solo exhibitions. Having a deep desire to promote creative expression and learning in the fields of sculpture, drawing, design, ecology, and the environment, the Kenneth Capps Foundation was established in 2011. This nonprofit organization has a 40-acre sculpture park devoted to artwork sited in a natural landscape located near Warner Springs. (Courtesy of Robert Myers.)

INDEX

Aaron, Diana, 62
Acuna family, 15
Aguilar family, 15
Alcaraz family, 17
Alles, Chester, 22
Antonopoulos, Phil, 57
Armour, Geoff, 34
ArtSplash, 65
Atkinson, Colonel, 82
Balma, Larry, 74
Barba, Martín, 113
Baugh, Jack and Nina, 61
Blackburn, Bob and Elaine, 102
Blackburn, Jake, 103
Boys of the Barrio, 12
Brown, Maxton, 34
Bruhn, Russ, 67
Capps, Kenneth, 126
Carrillo, Leo, 45
Castorena, Manuel, 36
Chain Gang, 104
Chandler, Scott, 119
Chase, Roy, 19
Chess players, 79
Christiansen, Chris, 37
Christiansen, Kay, 34, 37
Church Smith, Samuel, 13
Clinton, Matt and Tim, 109
Cole, Georgina, 42
Cooper, Denny, 84
Cooper, Mina, 72
Crisci, M.G., 106
Dankberg, Mark, 94
DAR, 50
Dominguez, Billy, 33
Dominguez, Sean, 112
Doty, Rick, 77
Dowdy, Richard, 76
Ecke, Paul, Jr., 39
Ecke, Paul, Sr., 38
El Bimbo, 30
Escobedo, Ofelia, 93
Eshelman, Rosemary, 97
Eshelman, Thomas, 117
Ferraro, Deb, 69
Fire Department, 31

Frazee, Mike, 96
Frazier, John, 22
Gage, Luther, 26
Garcia, Abel, 40
Garcia, Abel Jr. and Lawrence, 41
Garcia's Restaurant, 46
Gastelum, Bibiano, 11
Gastelum cousins, 12
Gonzales, Belynn and Alfredo, 46
Good, Roy, 59
Green, Doug, 100
Grismer, Larry, 71
Gutierrez, Susan, 90
Haedrich, John, 54
Havel, Helmut, 79
Hawk, Tony, 101
Helton, Red, 44
Henley, John and Ruth, 28
Henry, Paul, 107
Hughes, John, 114
Hummel, Emerald and Minnie, 47
Juncal, Ron, 124, 125
Kelly, Allan, 32
Kelly, Matthew and Robert, 16
Kelly, William and Vinnie, 17
Kentner, Eddie and Neva, 25
Kinley, Danielle, 123
Kirchmeyer, Swede, 52
Klopfenstein, Jay, 91
Kreutzkamp, Charles, 23
Kurner, Kristianne, 118
Kurner, Suzanne, 110
Ledesma, Linda, 89
Ledgerwood, Charles, 27
Lewis, Bud, 83
Lola's, 93
Lovaas, Cody, 121
Lubin, Marshall, 115
Lund, Carlton, 63
Maffucci, John, 86, 87
Magee, Hugh, 13
Malone, Glenn, 108
Marron, Juan, 24
Marsden, Clara, 56

Martinez, Ricardo, 14
McBride, Gina, 64
McClellan, Dewey, 43
McKaig, John, 48
McKaig, John, Jr., 49
McManigal, Jill, 95
Miringoff, Joni, 65
Moms-in-Touch, 72
O'Malley, John, 75
Pacheco, Leo, 92
Packard, Mark, 73
Parker, Becky, 80
Prelozni, Sue, 70
Prieto, Patricio & Francisca, 20
Ramsay, Betty, 42
Reid, Steve, 55
Riccitelli, Jeff, 99
Rotary, 50
Schutte, Bertha and Gerhard, 10
Senteno, Crespina and Alfonso, 21
Sheppard-Missett, Judi, 60
Shipley, Alexander and Florence, 18
Smith, Lance, 116
Snyder, Bryan, 111
Spanier, Jeff, 98
Spence, James and Marjorie, 28
Spindel, Anne, 68
Spineto, Erin, 78
Thomas, Ulises, 57, 120
Tomkinson, Andy, 122
Thompson, Sam, 66
Thorp, Brad and Beth, 85
Thorp Foundation, 85
Trejo, Connie, 93
Vantoch, Paul, 79
Vigne, Tom, 80
Walker, Karl, 88
Walton, Ralph, 35
Wadsworth, D.D., 28
Wanamaker, Al, 58
Waters, Amanda, 53

AN IMPRINT OF ARCADIA PUBLISHING

Find more books like this at
www.legendarylocals.com

Discover more local and regional history books at
www.arcadiapublishing.com